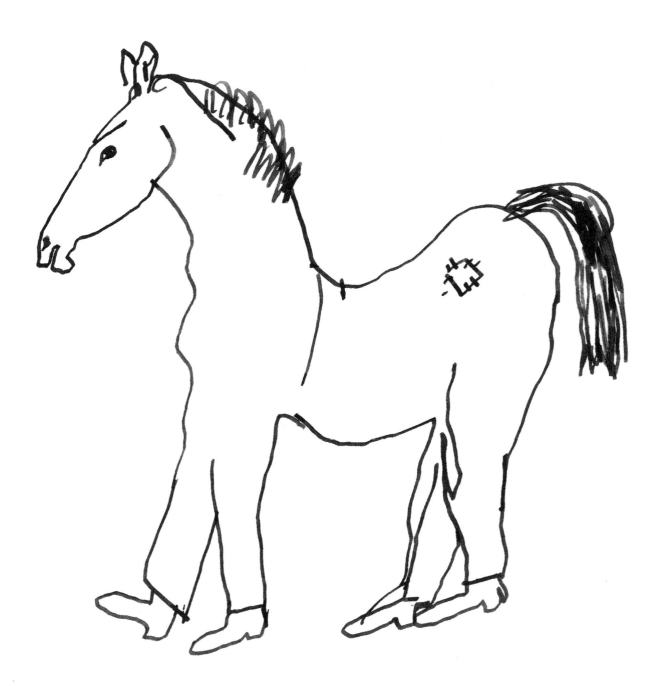

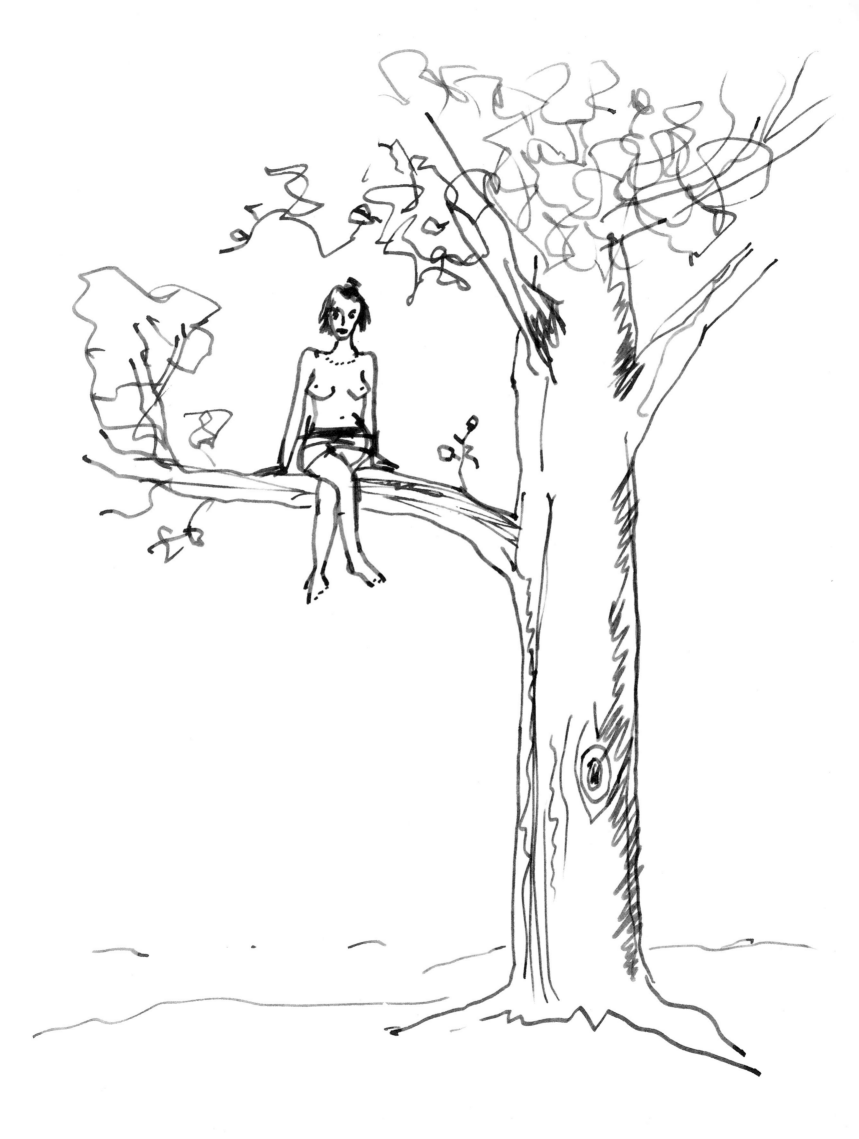

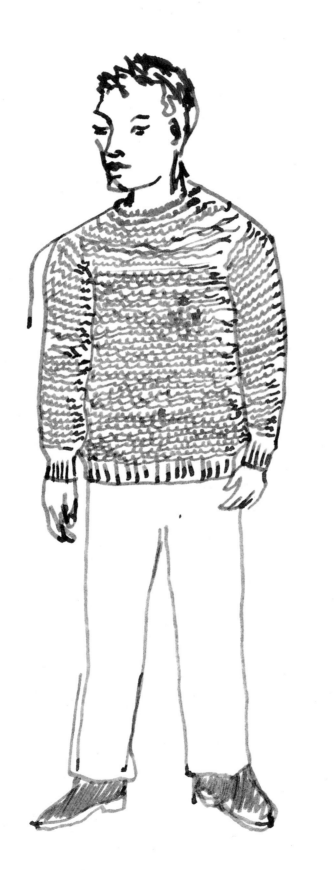

Der Pullover-Mann

Stephan Balkenhol

Printed as a benefit for
Contributing Members of the
Smithsonian Institution

Support for the exhibition "Stephan Balkenhol: Sculptures and Drawings"
and its accompanying publications has been provided by a grant from
Schmitter Media-Agentur, Frankfurt am Main, Germany.

Additional support was provided by the Institute for Foreign Affairs of the
Federal Republic of Germany.

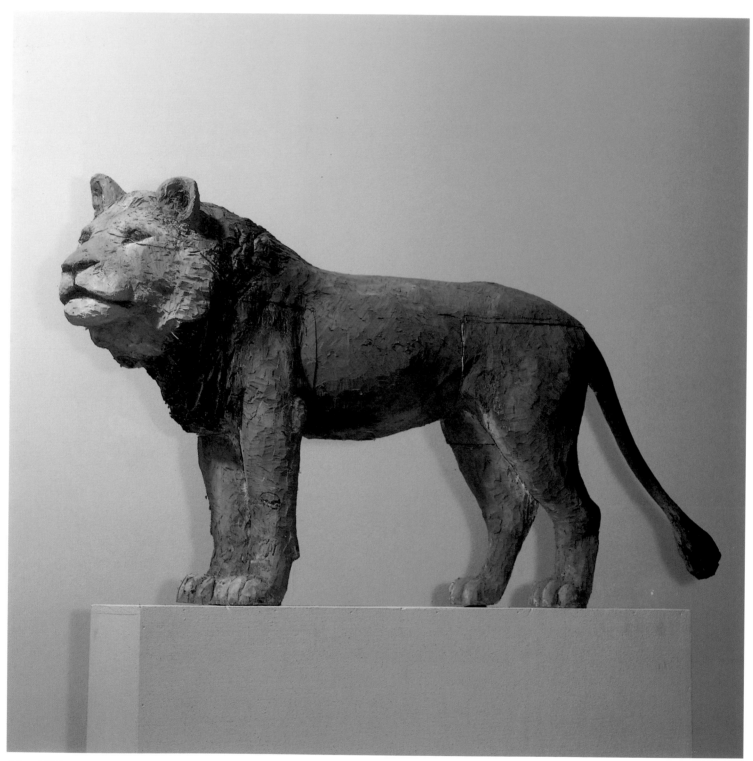

Lion, 1994, cat. no. 4.

Neal Benezra

Stephan Balkenhol Sculptures and Drawings

Hirshhorn Museum and Sculpture Garden
Smithsonian Institution, Washington, D.C.
in association with
Cantz Publishers, Stuttgart

Published in 1995 by the Hirshhorn Museum and Sculpture Garden, Smithsonian Institution, Washington, D.C., in association with Cantz Publishers, Stuttgart, on the occasion of an exhibition organized by the Hirshhorn Museum and Sculpture Garden.

Hirshhorn Museum and Sculpture Garden
Smithsonian Institution, Washington, D.C.
October 19, 1995 – January 15, 1996

The Montreal Museum of Fine Arts
February 15 – May 26, 1996

Cover: *Three Hybrids*, 1995, cat. no. 30.
Frontispiece: *Lion*, 1984, cat. no. 4.
Endleaves (front): *Untitled* (sixteen drawings), 1995, pen and ink on paper, each 11 1/2 x 8 3/16 in. (29.7 x 21 cm). Galerie Löhrl, Mönchengladbach, Germany.
Endleaves (back): *Sixteen Blackboard Drawings*, 1994, cat. no. 28.
Back cover: *Three Figures*, 1985, cat. no. 5.

Library of Congress Cataloging-in-Publication Data

Benezra, Neal David, 1953–
 Stephan Balkenhol : sculptures and drawings / Neal Benezra.
 p. cm.
 Catalog of an exhibition held at the Hirshhorn Museum and
Sculpture Garden, Smithsonian Institution, Washington, D.C., Oct.
19, 1995 – Jan. 15, 1996, and the Montreal Museum of Fine Arts, Feb.
15 – May 26, 1996.
 Includes bibliographical references.
 ISBN 3-89322-770-9 (acid-free paper)
 1. Balkenhol, Stephan, 1957– – Exhibitions. 2. Polychromy –
Germany — Exhibitions. I. Balkenhol, Stephan, 1957–
II. Hirshhorn Museum and Sculpture Garden. III. Montreal Museum of
Fine Arts. IV. Title.
NB588.B435A4 1995
730'.92 – dc20
 95 – 32948
 CIP

Contents

Three Hybrids, 1995, cat. no. 30.

Foreword

James T. Demetrion, Director

Three-dimensional art has always had a special focus at the Hirshhorn Museum and Sculpture Garden as evinced in the museum's name, but one is taken aback even today to find an occasional colleague or dealer abroad who surmises that the Hirshhorn collects and exhibits only sculpture. Obviously such exclusivity is not the case even though the museum's collection of nineteenth- and twentieth-century sculpture is virtually unparalleled by any other institution.

Sculpture, therefore, retains an important position here, and with this exhibition by Stephan Balkenhol — his first one-man show in a U.S. museum — we are privileged to introduce a rising young German sculptor to our public. We are especially pleased that the Montreal Museum of Fine Arts is playing a similar role in Canada through its participation in the exhibition.

Balkenhol's sculptures have frequently been described (sometimes with pejorative overtones) as "mundane" and "commonplace." In fact, the artist himself once referred to his type of individual human figure as Everyman, implying a transcendent sameness among the "twentysomething" youths he depicts. Even when they engage in hugely out-of-the-ordinary activities — sitting beside an enormous snail, wrapping one's arms and legs around the neck of a giraffe, holding one's own decapitated head — the facial features and expressions seem not out-of-the-ordinary at all. As in the *57 Penguins* (Everypenguin?), the differences from one of Balkenhol's figures to the other may indeed be discernible, but barely so. If one wishes to find a living Balkenhol, the artist seems to imply, just look at the person to your left or right, or perhaps add or subtract a few years and glance in the mirror.

This exhibition could not have been realized without the support of numerous collectors and other individuals who are mentioned in the author's acknowledgments that follow. I wish to express here my warm thanks to the current and former German ambassadors to the United States, Dr. Jürgen Chrobog and Dr. Immo Stabreit respectively, for lending their patronage to the exhibition. We are equally grateful to the Montreal Museum of Fine Arts and to its director, Pierre Théberge, for joining us as a partner in bringing these special sculptures and drawings to North America. Mr. Horst Schmitter, Schmitter Media-Agentur, Frankfurt am Main, has generously supported the exhibition and this publication. It gives me great pleasure to acknowledge his contribution. A grant from the Institute for Foreign Affairs of the Federal Republic of Germany has provided partial support for the exhibition, for which we are also particularly thankful.

Special recognition must go to Neal Benezra, the Hirshhorn's Director of Public Programs/Chief Curator, who conceived and organized the show and has written perceptively for this publication. Finally, we are most grateful to Stephan Balkenhol, whose cooperation and support have been invaluable throughout the preparation of the exhibition that bears his name.

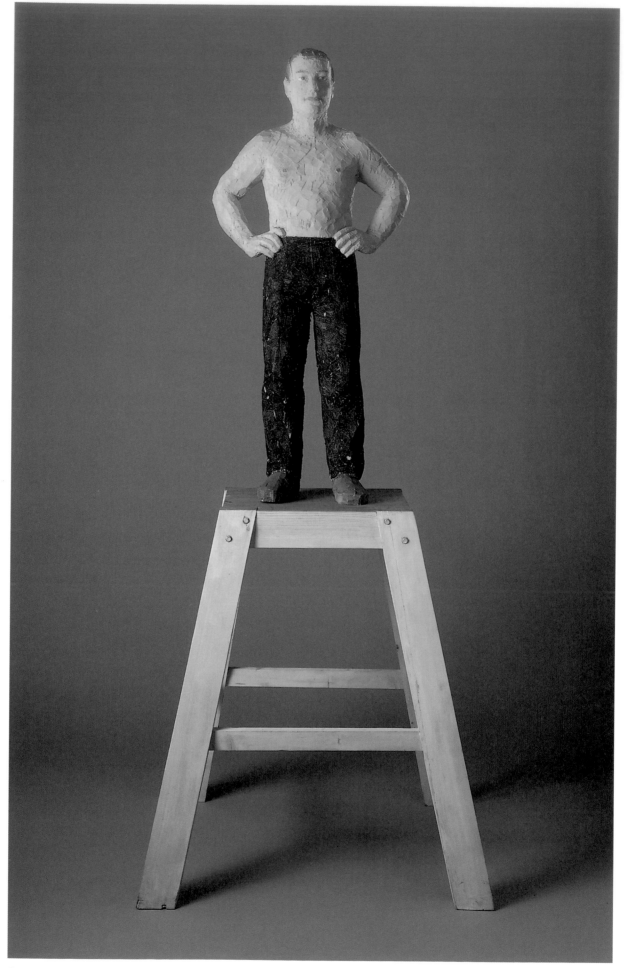

Man with Black Pants, 1987, cat. no. 6.

During the late 1980s and early 1990s, I had the good fortune to travel often in Europe. Those visits coincided with a period of great change, as with breathtaking speed Communism was ushered out and the Berlin Wall dismantled. Openness, optimism, and the refreshing possibility of social and political transformation were ubiquitous. Yet as my awareness of contemporary European work grew, I was disappointed to see that a number of young and accomplished artists, many with impressive bodies of work and strong reputations on the Continent and in the British Isles, were not receiving either gallery or museum exhibitions in the United States. There are numerous reasons for this, including long-standing differences in conceptual and aesthetic taste and a general lack of awareness among Americans about current European work. But there was a much more basic cause. The abrupt economic downturn that occurred toward the end of the 1980s had largely eliminated the booming international market in contemporary art that had existed earlier in the decade. The importance of that market trend can scarcely be overestimated. Under the circumstances, few commercial galleries in North America could afford to import work (especially sculpture) by young artists working abroad, who were thus rendered inaccessible to most Americans.

When I first encountered the sculpture of Stephan Balkenhol in an exhibition organized by the Kunsthalle Basel in 1988, I had none of these issues in mind. I was struck, rather, by the immediacy and originality of the work. Simply put, I had never seen sculpture of this kind before: common men, women, and, yes, animals, as the subject matter, rendered so memorably. Through deft alterations of scale, highly selective if broad paint application, and unfailingly innovative installations, Balkenhol had begun to invigorate a seemingly moribund tradition. The more I saw of Balkenhol's work, in permanent collections, group and solo shows, and outdoor installations, the more convincing was the artist's ability to make sculpture of quality and timeliness that could also communicate with a broad audience. By the time I had assumed my duties at the Hirshhorn Museum and Sculpture Garden early in 1992, I had begun to investigate the present show. The marriage of artist and institution proved to be ideal: the museum had acquired *Man with Black Pants*, 1987 (illus., p. 8), as early as 1989. Balkenhol updates the tradition of modern sculpture, which is amply in evidence at the Hirshhorn and, at the same time, speaks effectively to the enormous and general audience that daily visits Washington.

I am grateful to a wide variety of individuals whose support made this exhibition possible. Director James T. Demetrion gave his early and enthusiastic support to the project, and his lead has been followed by Deputy Director Stephen E. Weil; Museum Administrator Beverly Lang Pierce; and Special Assistant Carol Parsons. I have relied on the expertise of Museum Registrar Douglas Robinson; Exhibits Chief Edward Schiesser; Librarian Anna Brooke; and their respective staffs. In my own department of public programs, I am greatly indebted to Jane McAllister, Publications Manager; Sidney Lawrence, Public Affairs Officer; and Teresia Bush, Acting Senior Educator; and their colleagues. I want to make special mention of my assistant, Francie Woltz, for her unfailing dependability, and to my research assistant for this project, Stephanie Jacoby, who has worked with determination and skill in authoring the documentation section of this catalog, the most complete to

10 date on the artist. I would also like to acknowledge the enthusiasm of John H. Brown of the Smithsonian's Office of Development and his efforts on behalf of this project.

Outside the Smithsonian, my thanks go to Dr. Dieta Sixt, Director the Goethe Institute in Washington, D.C., for the many hours she has spent as an advocate of the exhibition. I am also grateful to a variety of friends and colleagues in the United States and Europe for their assistance, information, and hospitality. Among them are Jeffrey C. Anderson, Washington, D.C.; Ellen de Bruijne, Amsterdam; Alenka Klenenčič, Meisenthal, France; James Lingwood, London; and Maja Oeri, Basel. I am especially indebted to Horst and Vivien Schmitter, and to Stefanie B. Haueis of Schmitter Media-Agentur, for their friendly support. The artist's representatives have cooperated in exemplary and enthusiastic ways in helping locate works and supplying supplementary information. In particular, I would like to acknowledge Leyla Akinci, Galerie Akinci, Amsterdam; Mark Deweer and Jo Coucke, Deweer Art Gallery, Otegem, Belgium; Victor Gisler, Galerie Mai 36, Zurich; Barbara Gladstone, Barbara Gladstone Gallery, New York; Jörg Johnen and Ursula Debiel, Galerie Johnen & Schöttle, Cologne; Dietmar Löhrl and Birgid Schmittmann, Galerie Löhrl, Mönchengladbach, Germany; and Stuart Regen, Regen Projects, Los Angeles.

This catalog is the product of a lively and unusual collaboration among artist, curator, and publisher. I am most grateful to Bernd Barde, Markus Hartmann, and Gabriele Sabolewski of Cantz Publishers, Stuttgart, for their imagination and flexibility in developing this publication.

Finally, I am indebted to Stephan Balkenhol for his generosity and hospitality throughout the course of our collaboration. It has been my great pleasure to organize this exhibition and have a role in introducing his work on this side of the Atlantic.

N.B.

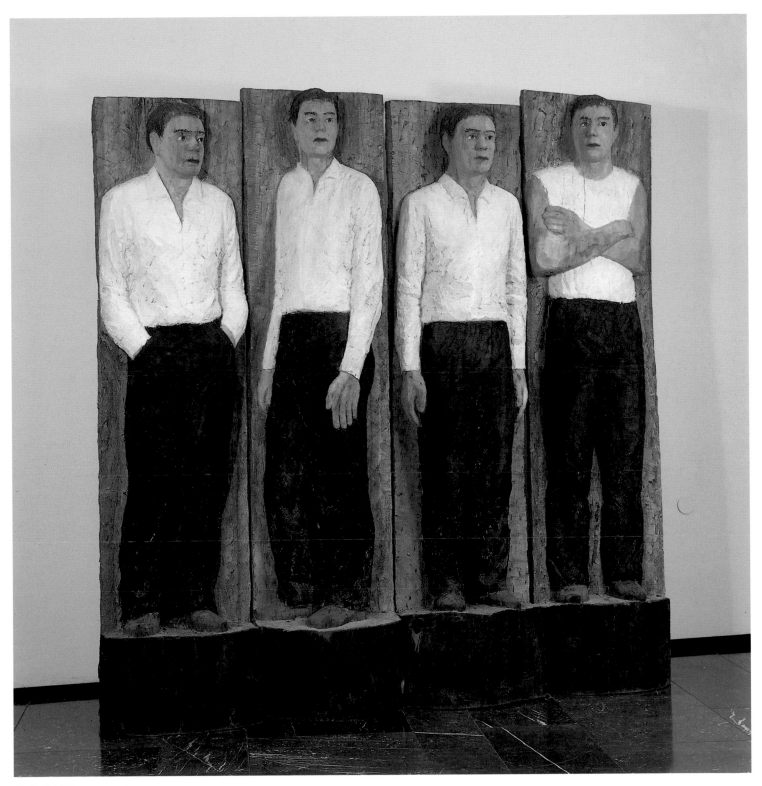

Relief, 1983, cat. no. 1.

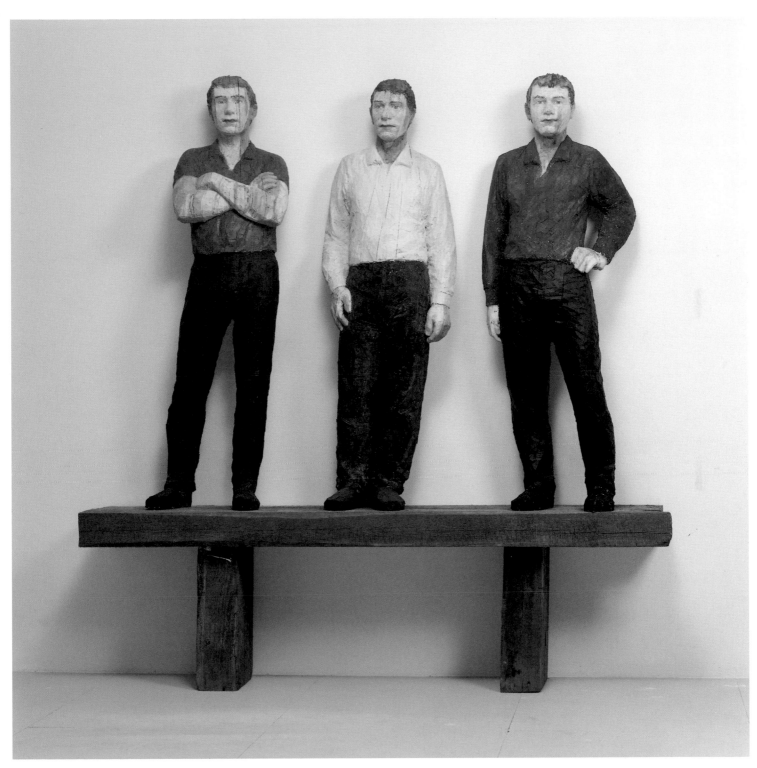

Three Figures, 1985, cat. no. 5.

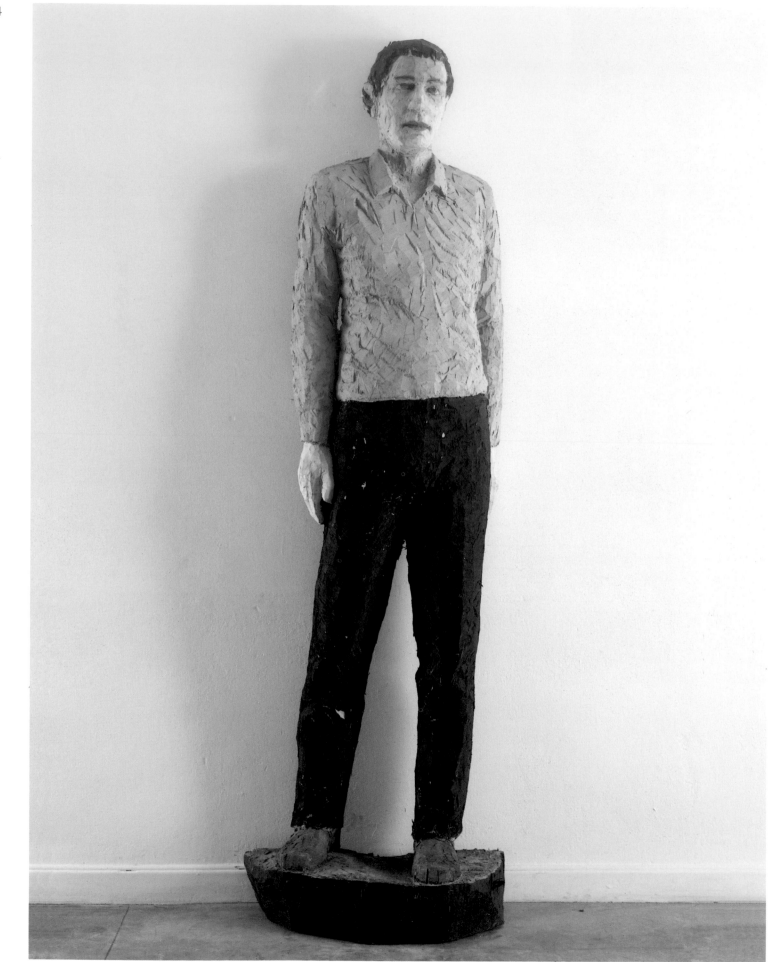

Large Man with Green Shirt, 1984, cat. no. 2.

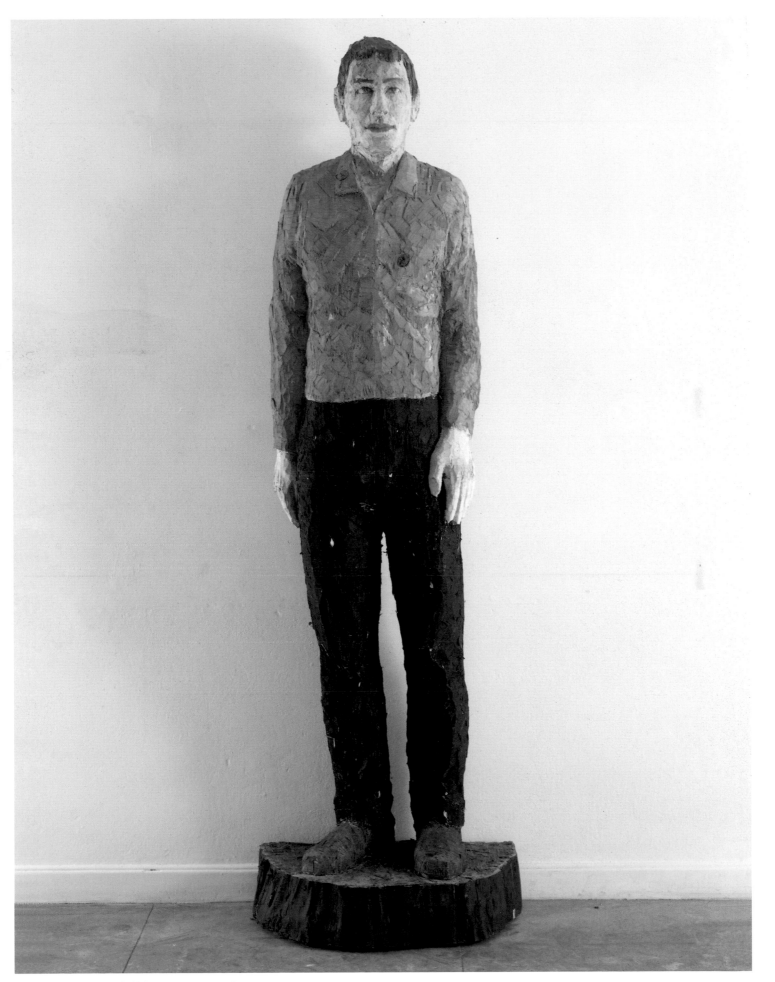

Large Man with Pink Shirt, 1984, cat. no. 3.

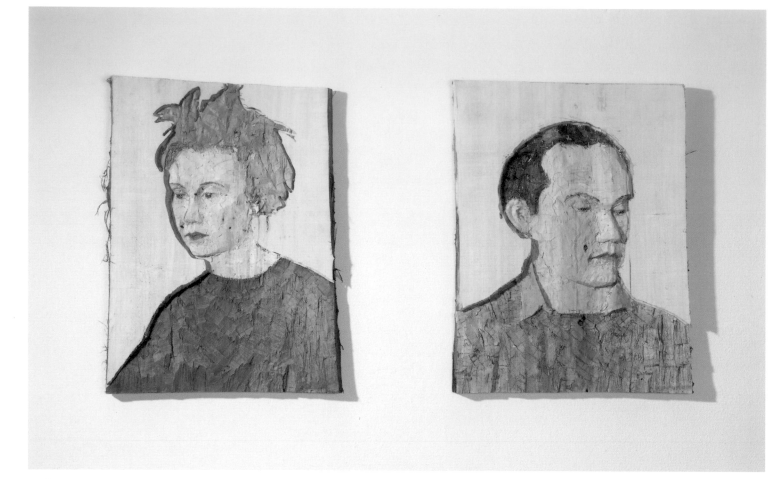

Relief Heads 1–6, 1988, cat. no. 7.

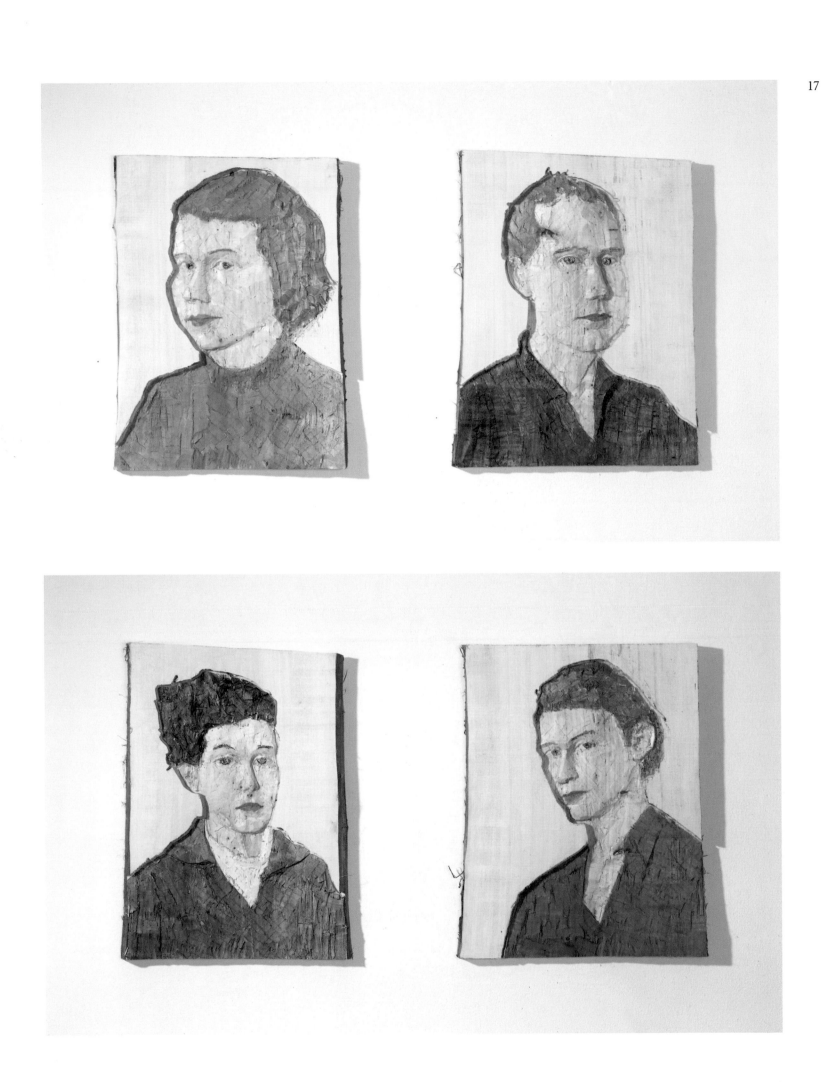

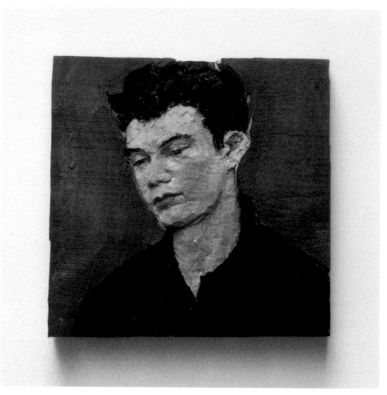

Small Relief (Man), 1990, cat. no. 11.

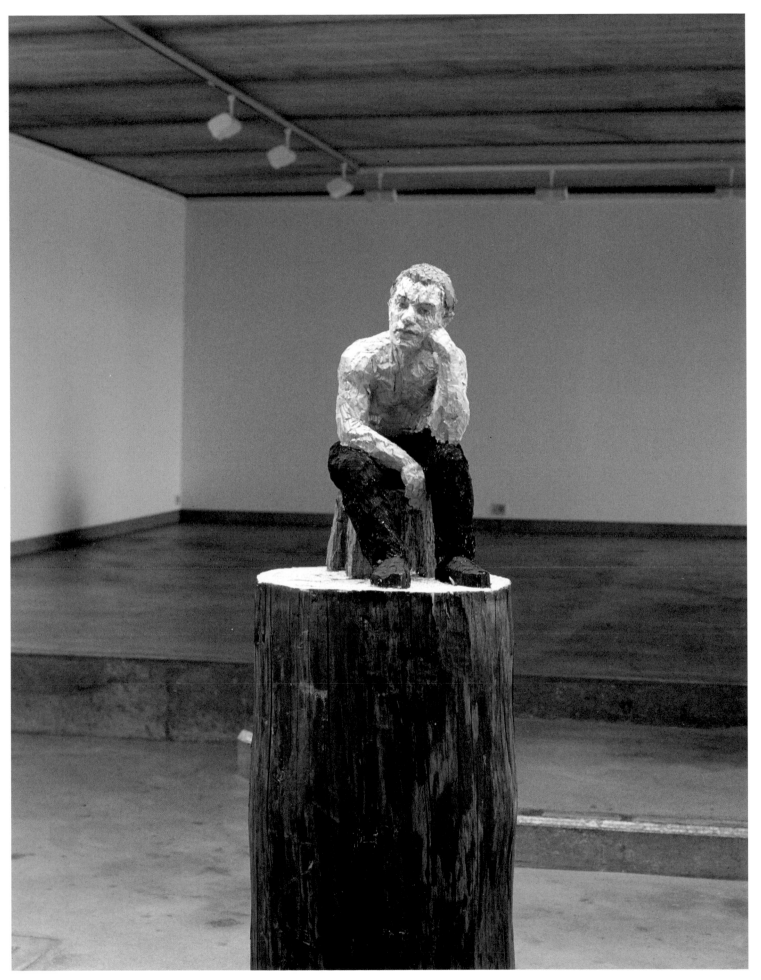

Seated Man, 1990, cat. no. 9.

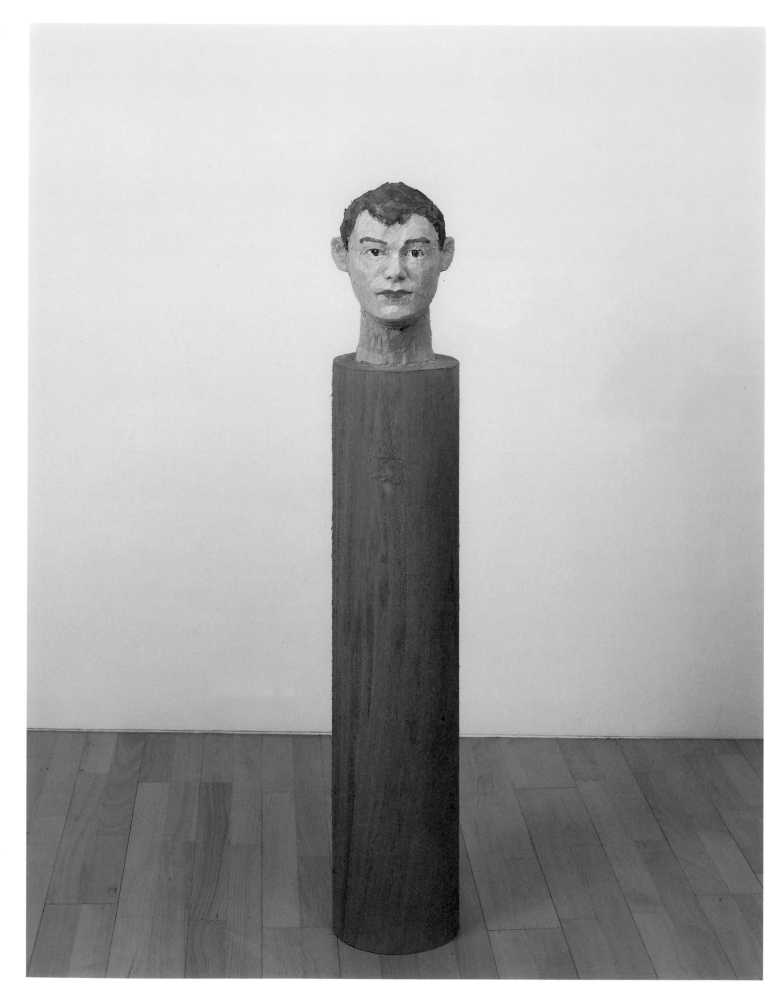

Head on a Column (Man), 1991, cat. no. 13.

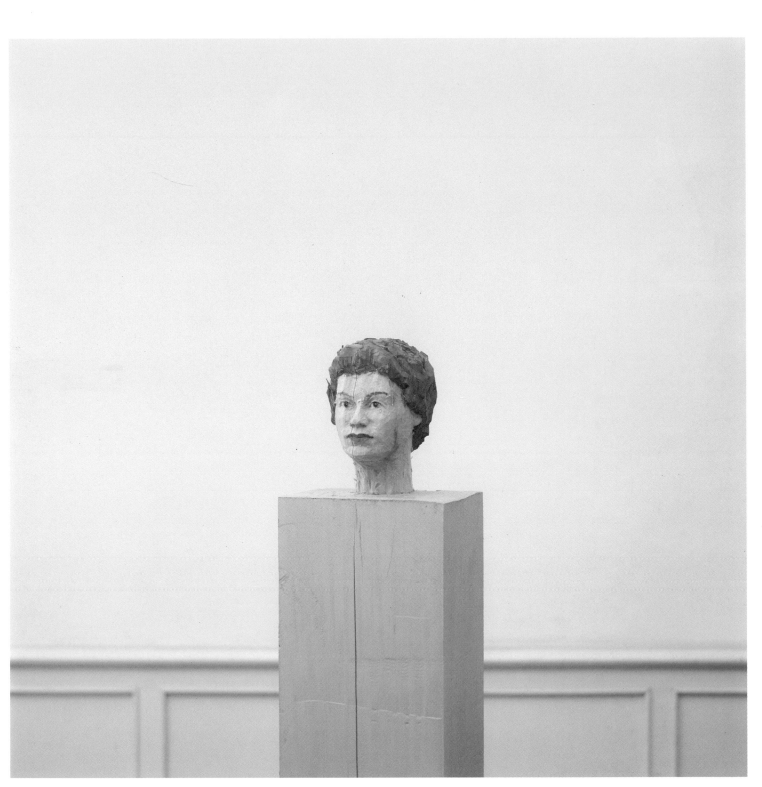

Head on a Column (Woman), 1991, cat. no. 14.

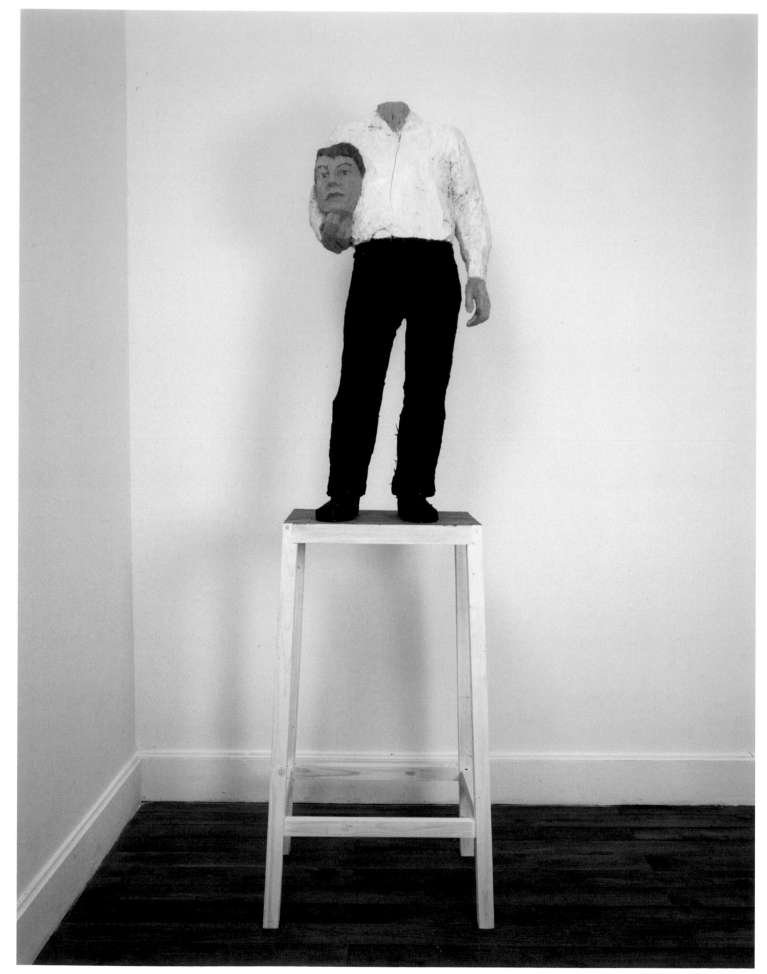

Man with Head under His Arm, 1994, cat. no. 24.

Stephan Balkenhol: Refiguring a Tradition

Neal Benezra

In February 1992 the young German sculptor Stephan Balkenhol placed *Standing Figure on Buoy*, an eight-foot-high carved and painted wood figure, atop a buoy in the Thames River in London (fig. 1). Appearing altogether human, the sculpture attracted the attention of numerous pedestrians and motorists, one of whom, as noted in the *Evening Standard*, "leapt into the river reportedly shouting 'Don't jump,' and had to be rescued himself by the River police, while the wooden sculpture looked on, unmoved." In the *Times* of London the critic Richard Cork wrote that "Balkenhol appears to be striving for the anonymity of Everyman — even if the statuesque form he adopts here was used in the past to dignify public effigies of the famous."[1]

The Thames River anecdote typifies Balkenhol's experience as a sculptor of public art and succinctly introduces his work and career. Balkenhol is concerned with attracting a broad audience for his sculpture, and one of the ways in which he does so is by reinvigorating the long-dormant tradition of siting figurative statues in public places. He does not seek to recapture the heroic glory of bygone periods but rather demonumentalizes the figurative statue by thrusting the most unremarkable men and women onto pedestals historically reserved for heroes and heroines. In the process the artist has engaged a wide range of viewers, namely, adults and children who need no prior experience of art to appreciate a sculpture encountered during the course of daily life. Not since Claes Oldenburg began to install his sculptures outdoors in the 1960s has a sculptor so successfully employed deadpan humor to draw people to art.

The reaction of many in the contemporary art community has been predictable: Surely this is not the stuff of serious art! Indeed, Balkenhol has established an unusual niche for himself outside what might be termed, paradoxically, the "progressive mainstream" of contemporary art. He has self-consciously veered away from the often pedantic debates among postmodernists in the 1970s and 1980s concerning the viability of the object and the problematic question of originality in recent art. Balkenhol's work flies in the face of conceptualists, who actively despise direct working processes and humor that lacks irony, and who admit the figure into serious consideration only in the context of photography or videotape. Although Balkenhol's work is the object of considerable dispute, irritation, and downright dismay among "progressive" artists, critics, and curators, the artist remains undeterred. At a time when all manner of political, social, and cultural dogma seems open to question, it may just be possible for Stephan Balkenhol to breathe new life into figurative sculpture.

We can best approach Balkenhol's work through a catalog published on the occasion of an exhibition held in Rotterdam late in 1992.[2] In addition to the accustomed trappings of museum exhibition publications — illustrations, essays, documentation, an interview, and numerous photographs — the little publication *Stephan Balkenhol: Über Menschen und Skulpturen/About Men and Sculpture* resembles nothing so much as the artist's scrapbook gone to press. The snapshots he included provide a pictorial record of his perceptions of sculpture — from his discovery of art as a child to images of objects and people that have amused and interested him. A rudimentary biography tells us that Balkenhol was born in 1957, the youngest of four

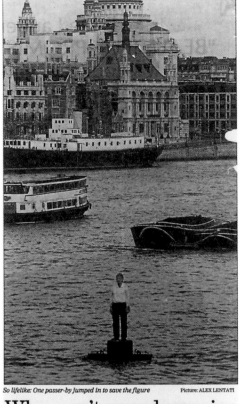

So lifelike: One passer-by jumped in to save the figure Picture: ALEX LENTATI

Why can't you dummies just let me alone?

by Robin Stringer

A SCULPTURED figure moored in the Thames off the National Theatre, part of a contemporary art show on the South Bank, has proved a little too lifelike for some caring Londoners.

Not only have they contacted security officers at the theatre and called police, but several have attempted to go to his rescue.

One even leapt into the river reportedly shouting "Don't jump" and had to be rescued himself by the River Police, while the wooden statue looked on unmoved. This kind of public response to German artist Stephan Balkenhol's bobbing figure is now worrying the authorities.

"We obviously don't want anyone to be harmed," said a spokeswoman for the Hayward Gallery, organisers of the exhibition called

Doubletake. "This poor person who jumped in had to be rescued himself because the water, apart from anything else, is pretty cold."

The wooden figure is considerably bigger than lifesize, standing over 8 ft tall. It may appear smaller because of its position some way out into the river. At the sugges-

tion of the River Police, the Port of London authority has now moved it from its original mooring, a buoy on which the figure looked particularly precarious, and put it on a much larger and safer-looking pontoon which rides higher in the water.

But some passers-by have still been sufficiently concerned at the sight to raise the alarm.

Fig. 1. *Evening Standard* (London), 28 February 1992.

24 sons, in Fritzlar, Hesse, West Germany.[3] His father taught German and history, and from 1963 to 1968 the family lived in Luxembourg, where the elder Balkenhol continued to teach and his youngest son became fluent in French. By the time the family moved to Kassel in 1968, Stephan Balkenhol was beginning to make collages and assemblages, as well as a few carved heads out of scraps of wood. That he grew up in Kassel is of great significance: every five years since the mid-1950s this Hessian city has played host to "Documenta," Europe's most important international exhibition of contemporary art. As luck would have it, in 1972 one of Balkenhol's older brothers, himself an art student, spent the summer selling catalogs and admissions to the exhibition. At age fifteen, Balkenhol visited "Documenta 5," where he was able to explore the exhibition for a thorough introduction to the latest developments in contemporary art. What attracted and doubtless held his attention was a pavilion called "Realism" curated by the well-known European curator Jean-Christophe Ammann. There Balkenhol saw an exceptional international survey of current painting and sculpture. The pavilion prominently displayed artists working with Pop ideas, among them Richard Artschwager, Jasper Johns, Malcolm Morley, and Wayne Thiebaud; the American Photo-Realist painters Robert Bechtle, Chuck Close, Richard Estes, Ralph Goings, and Paul Sarkisian; and the trompe l'oeil sculptors Duane Hanson and John De Andrea. Also noteworthy was the inclusion of Neil Jenney with his deadpan depictions of wry and quirky figures (fig. 2). Relatively few Europeans were included, but among them were Georg Baselitz, Franz Gertsch, and perhaps most notably, Gerhard Richter, represented by his remarkable *Eight Student Nurses* (fig. 3). Balkenhol recalls having been fundamentally influenced by the figurative work he saw at "Documenta 5," when he determined to "make my own Pop art."[4]

Fig. 2. Neil Jenney, *Girl and Doll*, 1969.

After graduating from high school in 1976, Balkenhol was admitted to the Hochschule für Bildende Künste in Hamburg. Although highly respected for its strong Minimalist and Conceptualist profile, and counting Nam June Paik, Sigmar Polke, and Ulrich Rückriem among its faculty at that time, Hamburg was nevertheless considered a less interesting and less desirable art school than the academy in Düsseldorf. The faculty in the latter city was dominated by the teaching and charismatic personality of Joseph Beuys, who had attracted a large coterie of students. Düsseldorf and nearby Cologne were preferred by most young German artists, yet Balkenhol chose Hamburg. Characteristically independent, he felt there were "too many artists in Düsseldorf,"[5] and he loved the physical beauty of Hamburg with its many bodies of water and brilliant summer light. Balkenhol would live in Hamburg on and off throughout the 1980s.

Fig. 3. Gerhard Richter, *Eight Student Nurses*, 1966.

As a student Balkenhol undertook several lighthearted conceptual and process projects around 1980 with a fellow classmate, Michelle Bourgeois. They focused on informal frozen-fabric installations, casting objects such as chairs, curtains, steps, and tunnels outdoors; when the forms thawed, the sculptures naturally collapsed in heaps (fig. 4). Around the same time, Balkenhol undertook more rigorous conceptual plans. He made an extended study of Longwy, a town in eastern France that has been devastated in recent decades by economic depression owing to the collapse of the region's mining industry. That project, now destroyed, involved extensive research, interviews, and photographic essays, and recalls similar photographic work by the contemporary German artists Bernhard and Hilla Becher.[6]

Balkenhol's most important relationship in Hamburg was formed with Ulrich Rückriem. Perhaps Europe's finest Minimalist sculptor, Rückriem is known for his work's rugged formal strength and its domineering but still-human geometry.

Facing page:
Fig. 4. Balkenhol and Michelle Bourgeois, frozen-fabric installation (destroyed), 1980.

Fig. 5. Photograph by Balkenhol of sculpture fragments.

Possessing a robust and forceful personality, Rückriem provided a formidable challenge for any student. He encouraged young artists to question all premises concerning the making of sculpture, and Balkenhol found him to be extremely open-minded. In retrospect Balkenhol would reflect, "It was very good for me to have artists as teachers who don't work figuratively such as Rückriem. . . . In that situation you ask different and fundamental questions." Balkenhol promptly became Rückriem's student and, eventually, his studio assistant.[7]

It was in Rückriem's classes that Balkenhol became serious about sculpture. He worked with a variety of materials — bronze, clay, granite, marble, and metal — fabricating a wide range of mostly small sculptures. He made numerous toy musical instruments, stone basins, and cubic forms. Linking the early conceptions, once again, is Balkenhol's iconoclastic playfulness. Together with his slightly earlier "frozen" sculptures, the objects satirized the self-consciousness and orthodoxy of Minimalism and Conceptualism.

Casting about for a subject, Balkenhol began to explore figurative sculpture. He quickly realized that he would "have to reinvent the figure," because, he has noted, "the tradition [had been] interrupted. At the time [I was studying], it was downright taboo to work figuratively. . . . I wanted to find out what [was] possible."[8] During the 1980s he visited the Hamburger Kunsthalle and also traveled to Cairo, Copenhagen, London, Munich, Paris, and Rome, studying the collections of figurative sculpture in the great historical museums and monuments of Europe. An energetic photographer, Balkenhol recorded images of Greek kouroi, Roman portrait busts, and monumental Constantinian fragments (fig. 5). He also made numerous drawings: small pen-and-ink sketches depicting the caryatids of the Erectheum in Athens (fig. 6), as well as a whimsical reinvention of the classical figures of *The Laocoön* struggling with the serpent (fig. 7). Already Balkenhol was employing humor as a tool in dismantling and reconsidering traditional figurative sculpture.

It was at that point, in 1981, that Balkenhol made his first, rough clay studies of heads. Their small gape-mouthed faces bear the exaggerated expressions of

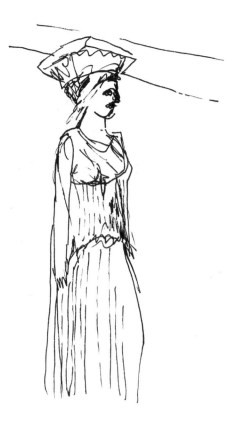

Fig. 6. *Untitled*, 1984.

Fig. 7. *Untitled*, 1981.

caricature. Although Balkenhol would work occasionally with concrete, plaster, and clay, he gravitated almost immediately to wood as his principal material.[9]

Balkenhol's first wood sculptures followed in 1982 and 1983. In the earliest pieces — *Male and Female Heads* (fig. 36, illus., p. 70) and *Man* and *Woman* (fig. 8) — he split a large log lengthwise, then carved figures from each of the two sides.[10] Balkenhol intentionally positioned the figures relatively high on the trunk and, as a result, each head is cropped just above the scalp. The carving is basic, the features heavy, and the gestures of hands and face awkward. Balkenhol painted the early sculptures in an equally abrupt manner, adding color only to highlights such as hair and lips while leaving the bare wood to render skin. By far Balkenhol's most direct and unrefined pieces, they unquestionably owe a good deal to Rückriem. Balkenhol had discovered his affinity for unhewed blocks of wood, just as his teacher had long ago found his with granite. The same deliberate ruggedness and feeling for materials and processes, balanced by a tactile, human quality, link the two artists' work.

The issue of how Balkenhol would respond to the history of wood sculpture soon arose. Figurative sculpture in wood has dominated the folk and the fine arts, particularly in Germany. The twentieth-century tradition is expressionistic, ranging from works by Ernst Barlach and Ernst Ludwig Kirchner early in the century to those by Georg Baselitz in recent years. While respectful of past achievements, Balkenhol cared not at all for the overwrought emotion that German Expressionism often conveyed. He quickly recognized that expressionist sculpture is distinguished by the nudity of the figures, the pathos of their hand and facial gestures, and the aggressiveness of the sculptor's application of paint. Balkenhol realized that if he could neutralize these expressive characteristics, then he could defy the expectations that would otherwise burden his figures. During the early 1980s, Balkenhol did exactly that.

It was natural, for example, for paired male and female nudes to be read in narrative fashion; his *Man* and *Woman* were immediately interpreted as Adam and Eve. Yet Balkenhol was clear from the outset that he did not want his work subjected to such obvious explanation. He desired just the opposite: "My sculptures are relatively realistic, [which] means they can all be recognized right away. They've got particular facial features and postures, yet they don't depict anyone in particular. They are not meant to tell a story either — they are not meant to have a narrative function."[11]

To avoid narrative or allegorical implications, Balkenhol determined to "clothe" his figures. One of his first such sculptures is *Relief* (illus., p. 11), a large work composed of four carved trunks, each bearing a full-scale, dressed male figure. An odd sameness permeates the group; the subjects, all young, are approximately the same height, and wear dark trousers and light-colored shirts. Only the mundane but uncomfortable positions of their hands distinguish them. It is unquestionably a peculiar detail for Balkenhol to call attention to, yet sculptors for centuries have had great difficulty composing hands. Balkenhol chose to make that aspect — and his natural if intentionally pedestrian solution — the very subject of the work. Here the Rotterdam "scrapbook" of 1992 is useful because it illustrates beside *Relief* a study that reads "Wohin mit den Armen" (Where to put the arms; fig. 9). In wonderfully lighthearted fashion, the subsequent pages are given over to Balkenhol's photographs of individuals and groups of figures in the street. Each conveys a different and completely unstudied expression with his or her hands. Finally, we see a photograph that Balkenhol made in the Glyptothek in Munich of an Archaic Greek kouros, hands held rigidly at his side as was characteristic in early classical art (fig. 10).

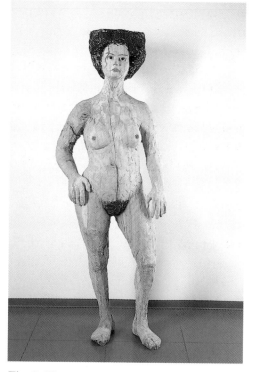

Fig. 8. *Woman*, 1983.

Balkenhol's approach here — combining an awareness of sculptural tradition, observations of human gesture and dress, and his own down-to-earth playfulness — now coalesced and formed a specific working process. With the early painted and "clothed" figures, Balkenhol established an attitude toward rendering the human form that would confound accepted practice but remain true to his own immediate perceptions. "Mimesis in this context can be understood in various ways," he has noted. "I don't mean only 'imitation' of the superficial level of reality, but also the reflection of the human relations to art, to reality."[12] In that sense, Balkenhol prefers Egyptian sculpture to Roman:

I am fascinated by their aura of eternity and tranquility. They seem to combine both: they emanate transcendence as well as reality and presence. There is almost something contemporaneous about them. Yet they are not realistic in the way of Roman sculptures which are more like three-dimensional photos.[13]

Stated differently, Balkenhol was attempting to work "in the gap separating art and life," to use Robert Rauschenberg's phrase. While Pop artists appropriated the imagery and materials of the street for their work, Balkenhol was attempting instead to make a hybrid figurative form, one that would derive equally from art and life.

Balkenhol works in subtle ways to defy obvious allusions to either sculpture or human nature. The first of his tools is the odd, unnatural scale that he conveys in his work. Even in the early sculptures, male and female figures are often precisely the same height. They are either too tall or too short, but never quite our size. That unnerving perception reinforces their separateness from us while it insures that we recognize them as works of art. "Sculpture that is not life-size seems to activate the space in which it is placed more. Also, it engages your imaginative powers much more. Life-size sculptures seem somehow less important."[14]

Second is Balkenhol's matter-of-fact application of paint. While Expressionists from Kirchner to Baselitz have used color to heighten the figure's expressive possibilities, Balkenhol adds color broadly to render shirts, pants, hair, and other details of anatomy and dress. Skin, however, is left the natural color and texture of the wood, allowing the sculptures to hover tantalizingly between anonymity and likeness, between muteness and narrative.

The sculpture's base, too, has served as a tool that Balkenhol began to utilize in the mid-1980s for subtly placing his figures just outside our experience. Since the advent of Minimalism in the 1960s, abstract sculptors have largely abandoned the base, opting instead to place their work directly on the ground and thereby control scale through size, shape, and color only. Balkenhol reintroduced the base, creating new formats to suggest an unnatural scale and to govern the viewer's perception. While each of the four young men in *Relief* stands on his own trunk, Balkenhol evolved yet another device in *Three Figures* (illus., p. 13). Here all the figures are under life-size and rendered in the round. They are mounted side-by-side atop a simple post and lintel base that elevates them above the viewer's eye level. Deftly composed, the figures assume a classical, frieze-like quality. This they achieve even though they bear not a single narrative trace. Instead they appear as three disassociated individuals linked only in a tight formal arrangement.

Balkenhol's ability to straddle a line between human activity observed on the street and the expressionism of traditional figurative sculpture has yielded some of his best and most interesting work. A pair of tall figures from 1984, *Large Man with Green Shirt* and *Large Man with Pink Shirt* (illus., pp. 14–15) — each more than ninety inches in height, were intended from the outset to serve as frontal gateway sculptures.[15] On the one hand, Balkenhol focused on a distinguished tradition in art,

Nohin mit den Armen

Fig. 9. Page from *About Men and Sculpture*, 1992.

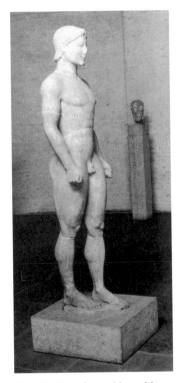

Fig. 10. Page from *About Men and Sculpture*, 1992.

one that has produced some of the most enduring monuments in the history of sculpture, in locations ranging from Babylon to Japan. Balkenhol's men parody the military figures who stand guard at important security or ceremonial entrances: erect, highly disciplined, tight-lipped. Their exaggerated height and slim proportions recall not the attenuated figures of Wilhelm Lehmbruck but rather two stiff and gawky men, thrust unnaturally, even comically, into the role of sculptural guardians. Similar in face and body type, they stand at nervous attention, simply waiting for something to happen.

Balkenhol's work of the mid-1980s was attracting the attention of European curators and he soon began to field invitations to participate in outdoor sculpture exhibitions. As a student of public sculpture, Balkenhol believed that Europe had been littered with ineffectual work particularly in the second half of the nineteenth century. What he termed a "flood of monuments"[16] had, in his mind, so abused the possibilities of sculpture that many progressive sculptors early in the twentieth century abandoned the figure altogether. Balkenhol is quick to point out, however, that while abstract sculpture has often supplanted figurative work in recent outdoor commissions, the proliferation of public abstraction has itself become academic: "A hundred years ago you saw in every park Amor and Psyche and sculpted *Adelstandbilder* [portraits of the nobility]. Nowadays you have modern sculptures by Richard Serra."[17]

Balkenhol's first opportunities to work outdoors came in the mid-1980s. Public sculpture produced a series of new challenges for him, among them questions of suitable content and durable material. In 1984, Balkenhol made a pair of lions, one of which, *Lion* (frontispiece, p. 2), was carved in wood and had to be assembled in parts. The other was cast in concrete and temporarily placed on view outdoors in Hamburg. A carver by temperament, Balkenhol found the process of modeling in plaster and then casting from the original to be somewhat tedious. Nevertheless, wood is ill suited for installation outside, and Balkenhol composed his first two major outdoor pieces — *Rider* (fig. 11), for the Jenisch Park outdoor sculpture exhibition in Hamburg, and *Man with Green Shirt and White Pants* (fig. 12), for the "Münster Sculpture Project" — in concrete.

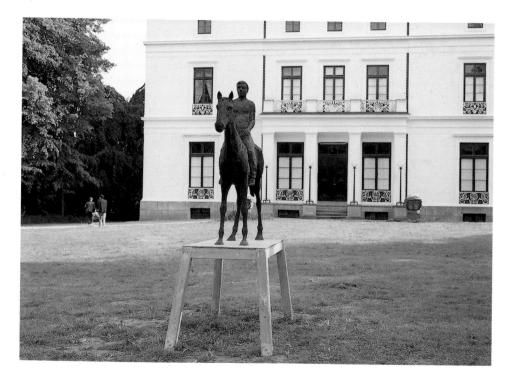

Fig. 11. *Rider*, 1986.

Facing page: Fig. 12.
Man with Green Shirt and White Pants, 1987.

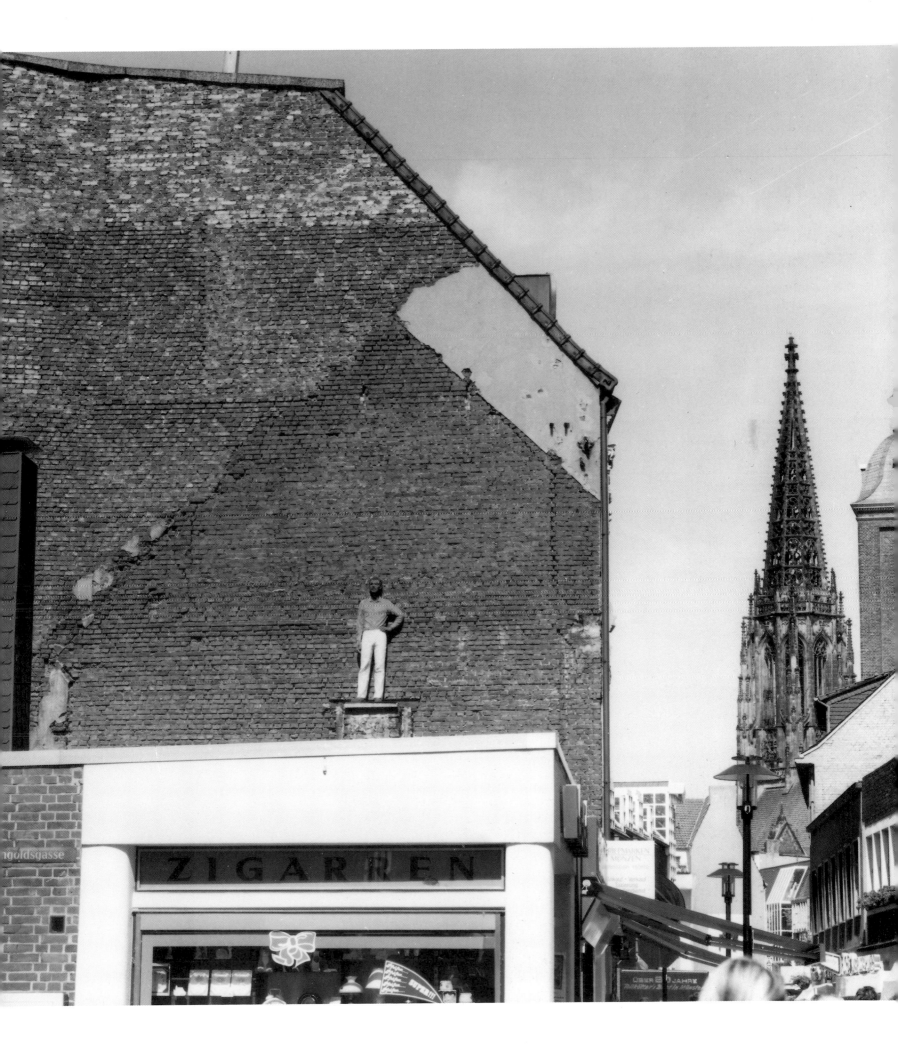

By his own admission, those two projects helped establish Balkenhol's attitude toward outdoor work. For the Hamburg exhibition, he placed *Rider* in a formal park. The artist noted:

Jenisch Park is a flawless English park. It really did not need any works of art because it is beautiful and complete in itself. For Rider, *I chose the circular space in front of the Jenisch House, where I could establish a connection to the building. In doing so, I was able to create a correlation between the house, the park, and the sculpture — a seemingly harmonious structure — modeled after a classical prototype. Only after taking a closer look did one become aware of the installation's dissonance. The equestrian sculpture did not blend in but instead made itself known by its smaller-than-life-size scale, its posture, its expression, and last but not least its makeshift pedestal.*[18]

The equestrian monument had fallen into disuse, and Balkenhol determined to test himself, not against artists such as Marino Marini of this century but rather against the glorious historical tradition. Long a vehicle for honoring heroic political and military achievement, the equestrian monument usually shows a rider astride a stallion and mounted high atop a pedestal chronicling the leader's deeds. Yet Balkenhol's rider defies those conventions. Physically unimposing and bare to the waist, he sits with his hands at his sides astride a bareback horse. Smaller than life, horse and rider stand together as the essence of stillness and repose. The tabletop base elevates the figures, but its unpretentious simplicity intentionally denies the sculpture any sense of monumentality.

The "Münster Sculpture Project" offered Balkenhol a quite different opportunity, in the form of a large and prominent exhibition of public art held in an urban setting. One of many sculptors commissioned to locate works around the city during the summer of 1987, Balkenhol diverged conceptually from those individuals who selected highly visible locations. Instead he chose to mount a relief on a nondescript and scarcely noticeable second-story masonry wall above a Münster tobacco shop. Having found remnants of a former chimney embedded in the wall, he selected an existing horizontal element to serve as a thin shelf on which to place his cast concrete sculpture *Man with Green Shirt and White Pants*. The siting was so surprising that one passerby actually mistook the sculpture for a man in danger and called the police.[19] That type of reaction would characterize public response to Balkenhol's subsequent outdoor work, as it did for his Thames River installation of 1992. The locations that he selects are so unexpected and so utterly convincing that the public can only assume that the figures are alive. The artist would later reiterate, "I prefer to see my work in the context of existing architecture and not in large, open spaces."[20]

Balkenhol's participation in the Münster project marked a breakthrough in his career. Although his work had been shown in several solo gallery shows and small museum group exhibitions, his sculpture had never been seen in such distinguished company. The "Münster Sculpture Project" had been held previously in 1977, and the 1987 exhibition was organized by two well-known German curators, Klaus Bussmann and Kasper König, who invited many of the leading sculptors in Europe and the United States to participate.[21] Beyond its visibility the show was historically important, for it chronicled a crucial shift in attitude among sculptors regarding the concept of site specificity. One of the assumptions underlying Minimalism and Earthworks in the 1960s and 1970s, site specificity originally held that the sculptor may exercise creative and sometimes absolute control over a given location. Granted artistic if not legal custody of the site, artists were often quite willful in applying their formal conceptions. In its purest expression, site-specific sculpture has taken the

Essay continues on page 42.

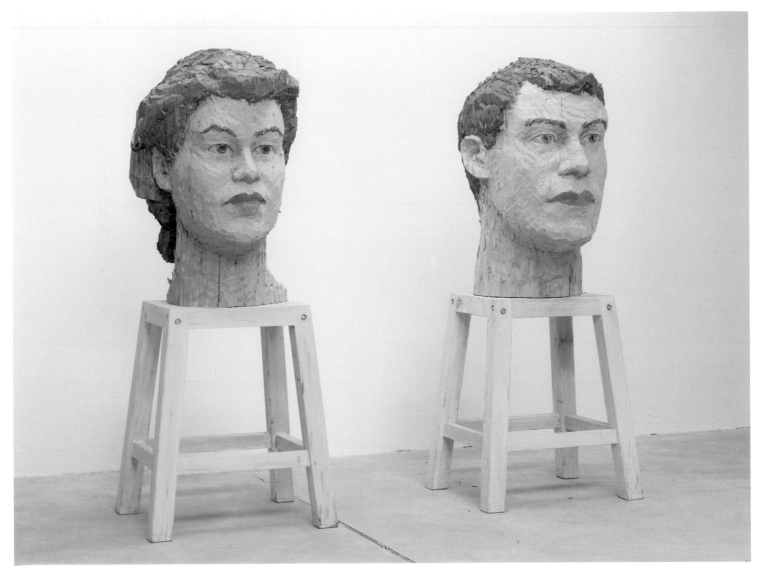

Large Couple (Heads of a Man and a Woman), 1990, cat. no. 8.

Sculpture Cross, 1991, cat. no. 15.

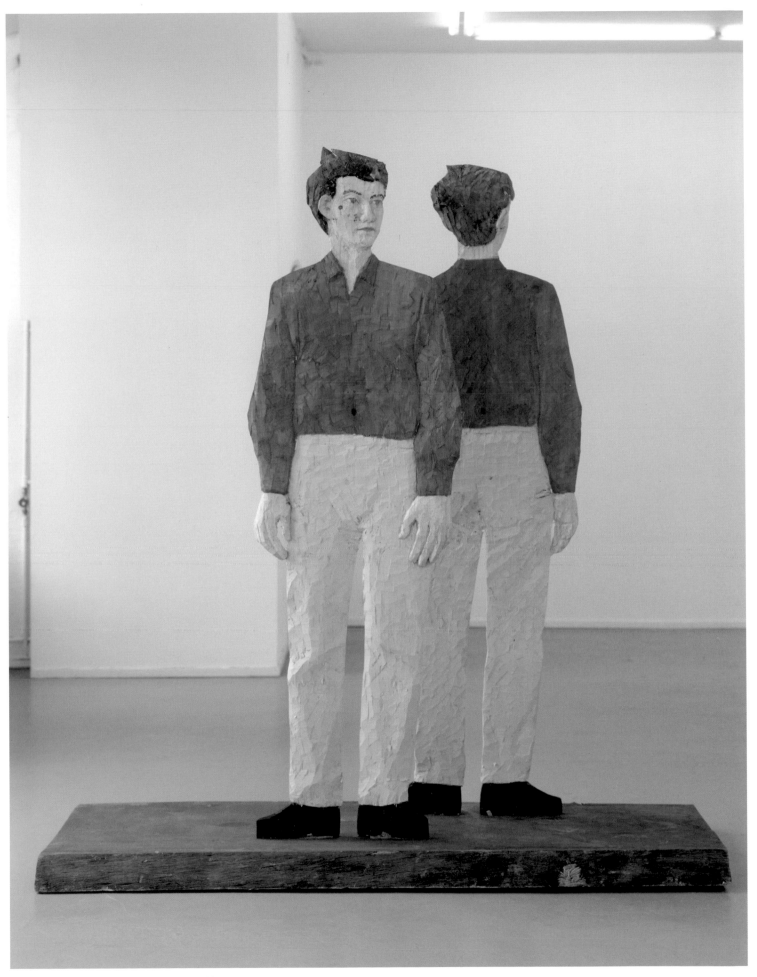

Double-Identity Figure, 1992, cat. no. 18.

Tondi (*Head of a Woman/Head of a Man*), 1993, cat. no. 21.

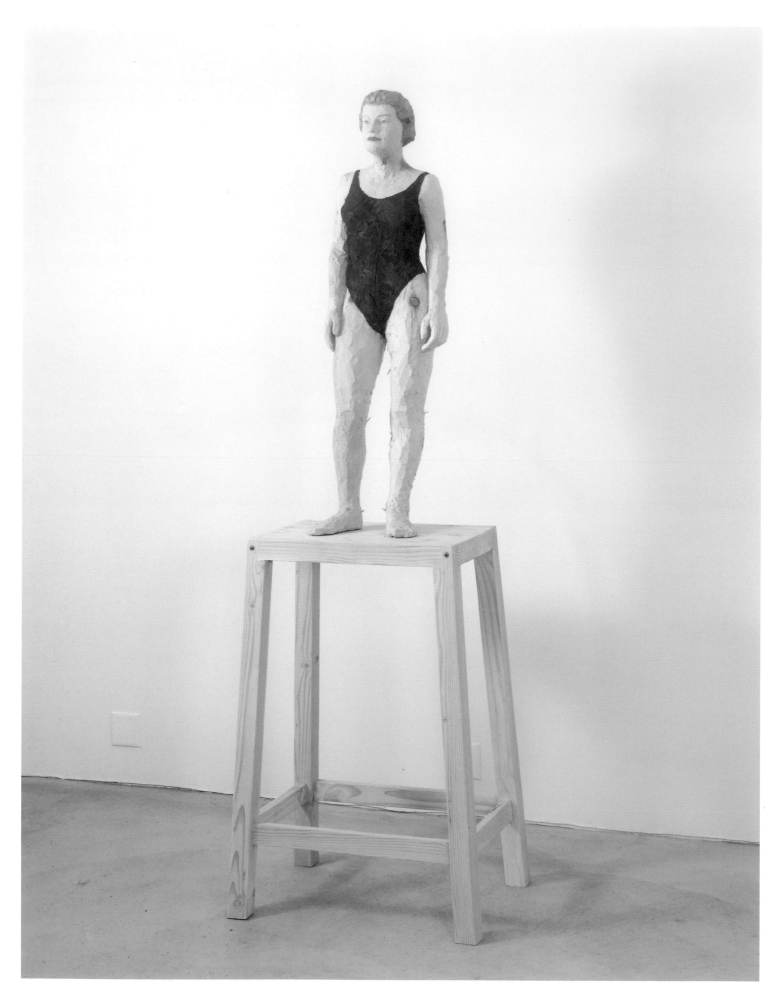

Woman in Green Bathing Suit, 1993, cat. no. 22.

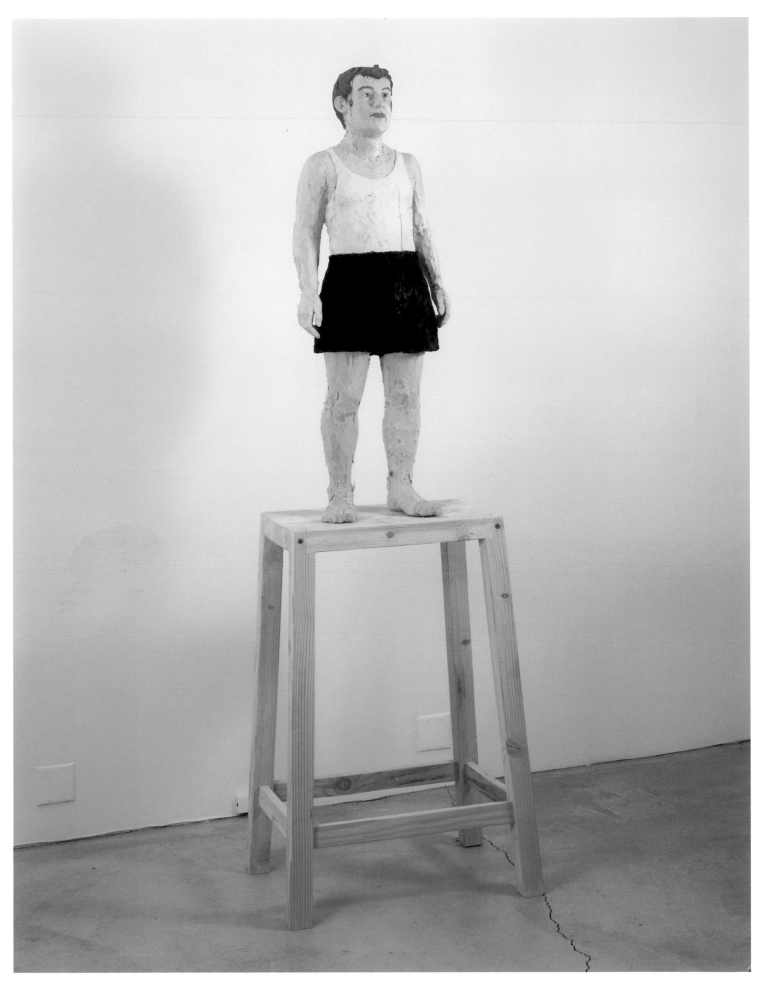

Man in Black Trunks, 1993, cat. no. 19.

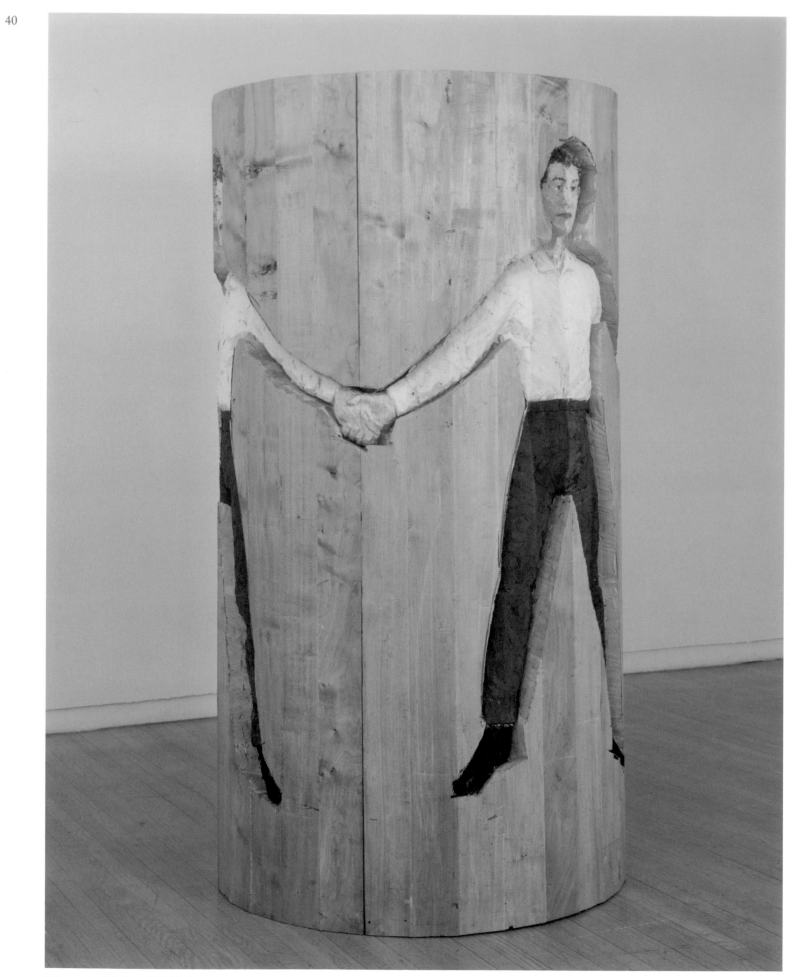

Volume Reliefs I and II (Male and Female), 1995, cat. no. 31.

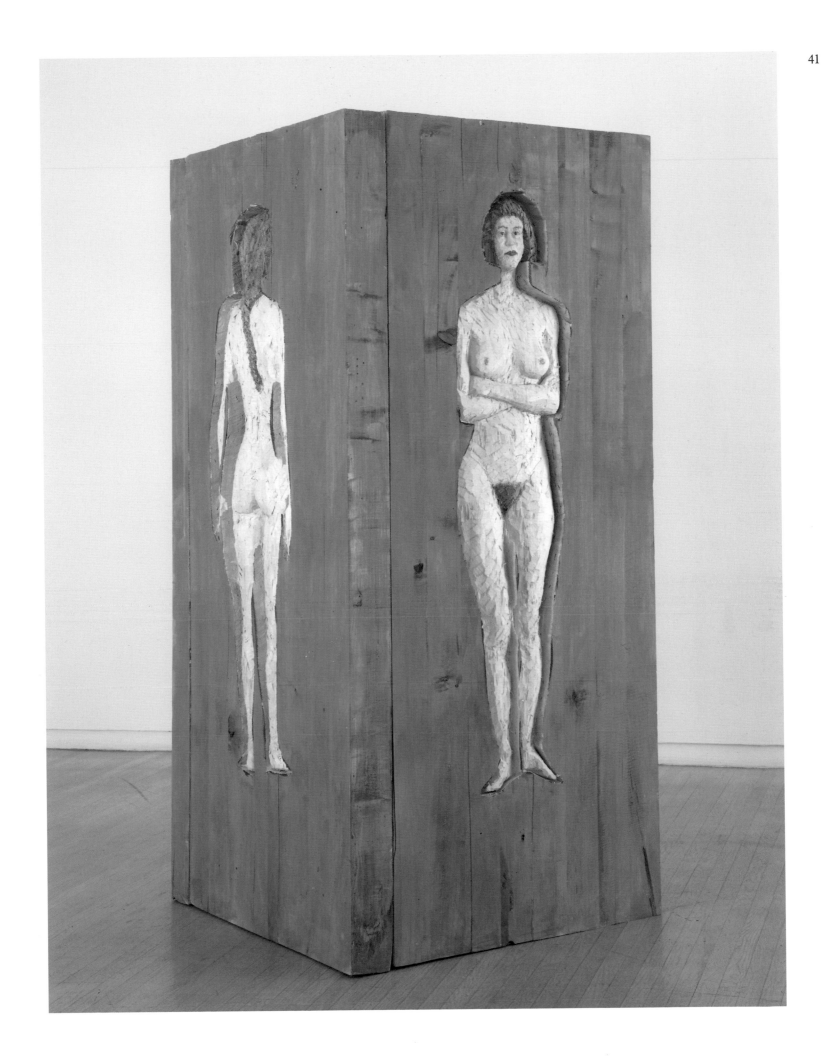

42 form of enormous visionary excavations in the landscape by Michael Heizer, Robert Smithson, and, more recently, James Turrell. On the other hand, Minimalists and Post-Minimalists such as Carl Andre, Robert Morris, and Richard Serra have created monumental site-specific sculptures. Whereas the Earthworks sculptors altered the landscape, Minimalists most often self-consciously imposed their own highly personal formal vocabulary on a given location. Perhaps the two most historically noteworthy site-specific sculptures are Smithson's *Spiral Jetty*, 1970, the bulldozed rocky spiral that extended into the Great Salt Lake and was eventually submerged when the water level rose, and Serra's *Tilted Arc*, 1981, in lower Manhattan, which the artist proclaimed destroyed after the controversial and unpopular work was removed.

The 1987 "Münster Sculpture Project" included a number of traditional site-specific works, among them a particularly well-integrated sculpture by Serra, *Trunk* (fig. 13), an enormous parenthesis in rolled steel placed near the entrance to the Erbdrostenhof Palace. Interestingly, Ulrich Rückriem's *Cut Dolomite*, 1976, a series of nine dolomite monoliths installed for the 1977 "Münster Sculpture Project" and removed in 1981 after prolonged public criticism, was now reinstalled in a new location. And yet, if the pieces by Serra and Rückriem were accomplished, the most compelling works in the exhibition were arguably made by younger artists, whose responses were of a different order. Rather than emphasize monumental formal statements, they reacted flexibly to their chosen sites, and their works had as much to do with content as with form. The distinction might be stated this way: whereas the older generation "imposed" a solution on a site, the younger sculptors "intervened."

The works by the younger artists represented in the Münster exhibition are among the best known and most important sculptures in their respective oeuvres. Rebecca Horn's *Concert in Reverse*, 1987, was installed in the Zwinger, a sixteenth-century civic fortress and former prison. The edifice had been used as a shelter during World War I and as a prison toward the end of World War II. Nearly destroyed at the conclusion of the latter, the Zwinger had been closed to the public ever since. Horn obtained permission to open the structure and install a number of objects inside, among them forty motorized hammers that struck poetically against various surfaces in the building. Jeff Koons recast in stainless steel (fig. 14) a popular Münster landmark, the *Kiepenkerl*, a small sculpture in bronze devoted to a farmer carrying produce to market in a basket. The original sculpture, which had been destroyed in World War II, had been replaced by a replica in 1953.

Horn and Koons dealt with local history and interceded on a psychological level, but each employed a vocabulary of form and content that was consonant with their previous work and recognizably their own. For other artists, such as Thomas Schütte and Katharina Fritsch, site specificity offered an opportunity to demonumentalize public art through unorthodox content and even mundane siting. In *Kirschensäule*, 1987, Schütte paid an ironic, Pop-inspired tribute to the cherries grown throughout the region, placing them high atop a base located in a parking lot. Fritsch sited her human-size *Madonna* (fig. 15), a bright yellow polyester replica of the Madonna of Lourdes, squarely on the ground in the midst of a pedestrian area near the Dominican Church.

Balkenhol shared these artists' determined deconstruction of site-specific sculpture, but works such as *Rider* and *Man with Green Shirt and White Pants* find the artist pursuing other ends as well. Here a more direct comparison with Koons is instructive. Koons's work and the ideas and strategies that underpin it resonate strongly in contemporary art-world practice. He designs his sculptures from existing

Fig. 13. Richard Serra, *Trunk*, 1987.

Fig. 14. Jeff Koons, *Kiepenkerl*, 1987.

prototypes, and the works are manufactured by skilled artisans. In the process he tests the boundaries separating sculpture and kitsch, questioning traditional definitions of intrinsic and monetary value in art. In contrast, Balkenhol is the consummate maker, carving his sculptures by hand without assistance. His processes notwithstanding, Balkenhol's reassessment of sculpture's history is broad based and sweeping, ranging from the history of equestrian monuments to a redefinition of public figurative statuary. Perhaps for the first time in Western art, simple figures — unaffected men and women engaged in no discernible activity — are placed in the most unlikely public locations.

Balkenhol's unusual position in contemporary art was the subject of an essay published by the artist Jeff Wall in 1988.[22] Wall discusses Balkenhol's work in the context of sculpture in the 1970s and 1980s, tracing the virtual banishment of the body from most progressive art during the modern period, and the debasement of public figurative sculpture at the hands of official commissions. For Wall, the virtual abolition of the figure — except from photography and videotape — assumed almost ideological proportions in some circles during the 1980s, when any reference to the individual was considered heretical. In Wall's estimation, Balkenhol's work held out the possibility that progressive artists might reconsider figuration without yielding to needless historicism or saccharine expressionism. Wall wrote that Balkenhol's work is "rarely nude, and it carries no attributes of occupation, labor, or engagement. It develops as an incompletely particularized human figure, neither shrunken into meager individuality and solitude, nor a transcendent *Denkmodell* [abstract idea], either classicistic or neo-expressionist." Wall continued to characterize Balkenhol's "pale monadic figures" as

> *people who have recently come out of the hospital after a serious illness, who cannot yet really return to active life, but who can get dressed normally and face things again. Like convalescents, their primary occupation is to complete their recovery. Soon, they may take up their tools and re-enter their complex, stressful social relationships.*[23]

Among the earliest instances in which Balkenhol's contemporaries have written about his work, the occasion for Wall's essay was the catalog accompanying Balkenhol's first touring show, organized by the Kunsthalle Basel in 1988 and seen subsequently in Frankfurt and Nuremberg. If the outdoor projects for Hamburg and Münster had occupied much of Balkenhol's time in 1986 and 1987, the Basel exhibition showed the artist pursuing new directions in his studio work. Foremost among these was a new interest in bas-relief. His earliest works in the format, *Relief Heads 1–6* (illus., pp. 16–17) are studies on six irregularly shaped poplar panels. For the first time, Balkenhol carved from life, with sitters present in the studio. If his spontaneous method was impressionistic and potentially expressive, the results remained restrained: each individual is portrayed in generalities.

Balkenhol followed the six panels with *Twelve Friends* (fig. 16), a series of twelve bas-reliefs depicting six young men and six young women now mounted in a grid. The title *Twelve Friends* subtly suggested the possibility of portraiture, a prospect that Balkenhol has consistently and emphatically rejected. What could not be denied, however, was his uniform depiction of youthful subjects — figures clearly of the artist's own generation. Balkenhol came to be compared most often to Wall — in particular, his work was likened to Wall's early series "Young Workers" (see fig. 17) — and to Thomas Ruff, who was photographing young men and women with clinical objectivity based on the relative sameness of their age, dress, pose, and facial expression (fig. 18).

Fig. 15. Katharina Fritsch, *Madonna*, 1987.

Overleaf: Fig. 16. *Twelve Friends*, 1988.

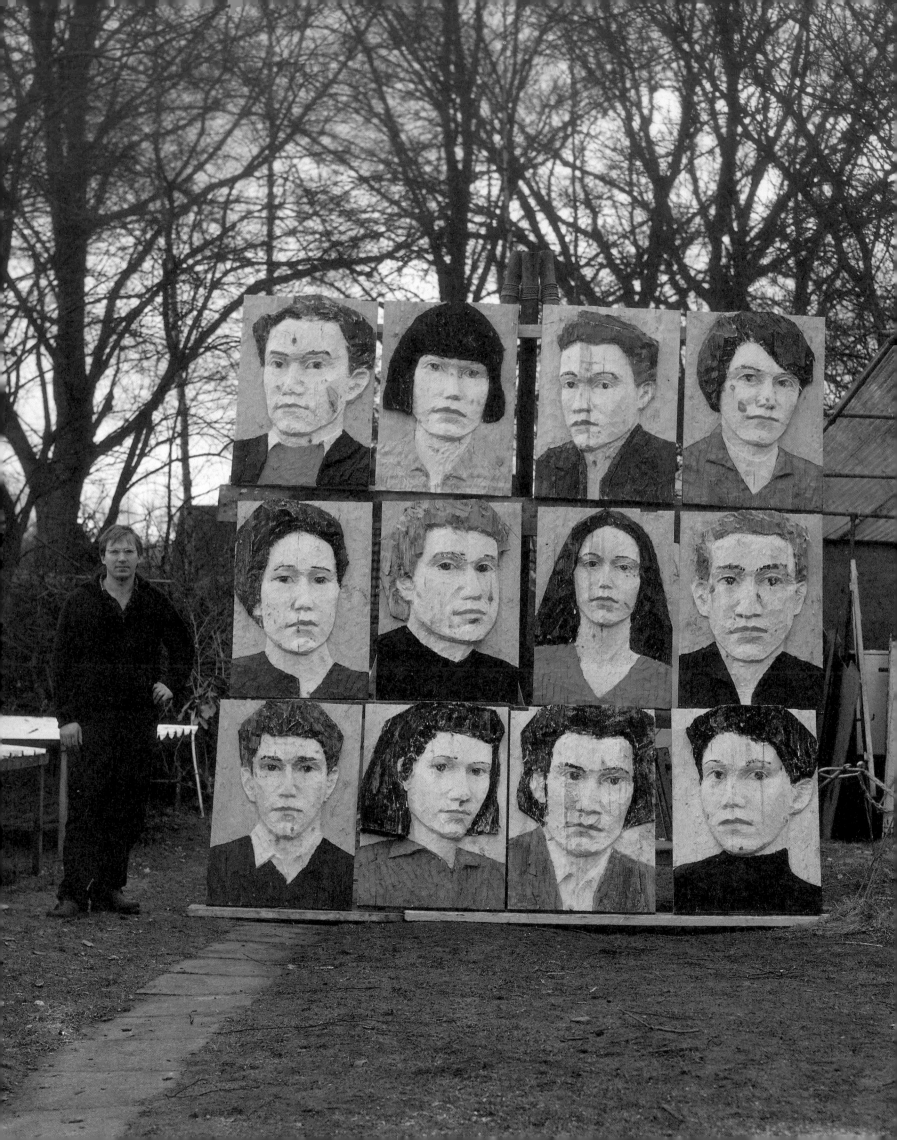

Considered within the modern tradition, Balkenhol's *Twelve Friends* touches upon two separate but related directions. The first involves photographers of an analytical bent who employ the camera as an archaeologist might — to construct methodically a precise if not objective typological record of quite specific subjects. Here one can mention works by a wide variety of artists in this century: August Sander's *Face of the Times*, begun in 1924, Bernhard and Hilla Becher's images of industrial structures from 1957, as well as the more recent works of Wall and Ruff. The other direction is similar formally but less analytical in its reliance on secondary photographic sources. Here one can name Andy Warhol's *Thirteen Most Wanted Men*, especially as the canvases were installed at the New York World's Fair in 1964 (fig. 19), and Gerhard Richter's *Forty-Eight Portraits*, 1971–72.

Balkenhol's *Twelve Friends* is striking for its open-endedness and the distance that the artist maintains from dependence on photographic veracity. Although he made the individual portraits of *Relief Heads 1–6* from life, that manner of working was highly unusual for him: Balkenhol does not use a camera in preparing his sculptures, and his drawings of figures and faces provide only the most generalized memory aides. In their attitude and realization, each of the "twelve friends" bears what might be termed an economy of representation, for each is perhaps closer to fiction than to fact. In a recent catalog essay, Jean-François Chevrier and James Lingwood wrote that "description can be in itself a form of fiction,"[24] a notion that surely applies to Balkenhol's sculpture even when it most closely approaches specific portrayal as in *Twelve Friends*. Here Balkenhol's art has more in common with Warhol's and Richter's than with photography. Indeed, in the translation from photographic original to reproduction to the final work, any archaeological impulse is dismissed in favor of the infinite possibilities of fiction.

Fig. 17. Jeff Wall, *Young Worker*, 1978–83.

Fig. 18. Thomas Ruff, *Portrait*, 1989.

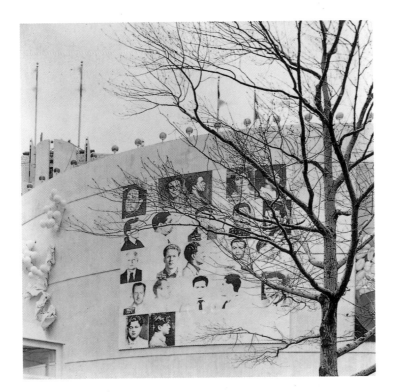

Fig. 19. Andy Warhol,
Thirteen Most Wanted Men, 1964.

In 1990, Balkenhol mounted a show of drawings and sculptures at the Deweer Art Gallery in Otegem, Belgium. The exhibition marked the first time he gave public prominence to his works on paper. In these small, quickly rendered studies, Balkenhol's quirky sense of humor is readily apparent. The cover of the catalog (fig. 20) clearly resembles German student composition books and also recalls Roy Lichtenstein's painting *Composition I* (fig. 21). Balkenhol has continued to combine the unstudied, offhand approach to drawing one sees in the work of Sigmar Polke and Robert Gober with the humor of *New Yorker* cartoons; his sketches are unfailingly witty in conception and executed in abbreviated, cartoon-like fashion. Many (such as a curvaceous classical nude resting comfortably on his carpentry bench, fig. 22) refer lightheartedly to his life in the studio, while others whimsically capture scenes based in history (figs. 23 and 24).

Fig. 20. Catalog cover, 1990.

Although Balkenhol had previously sculpted an occasional horse or lion, around 1990 he turned to animals as a regular subject in his drawings and sculpture. He selected animals on the basis of their anatomical peculiarity and often coupled them with small human figures. The two earliest examples are *Small Man on a Giraffe* and *Small Man on a Snail* (illus., pp. 53, 56).

The most compelling of Balkenhol's animal sculptures, and doubtless his best-known work to date, is *57 Penguins* (illus., pp. 48–49). Completed in just ten days in 1991, the fifty-seven penguins and their respective bases were carved from individual blocks of wood and painted with Balkenhol's characteristic energy and enthusiasm. To make the piece, Balkenhol studied penguins in books and zoos. Some of the resulting drawings are from life, some from fantasy; in one, the artist depicts a penguin peering curiously at a man who stands stiffly in black tie and tails. Each of the finished sculptures is uncannily alive and natural: some of the penguins shake frenetically, others preen lazily, while others simply doze beneath an unseen warm sun. When first exhibited at the Galerie Johnen & Schöttle in Cologne in 1991, the informal arrangement of the sculpture recalled nothing so much as Warhol's sculptures of the 1960s devoted to boxes of soup, soap pads, or cereal. Like Warhol and Oldenburg, Balkenhol disarms us with the witty innocence of his subject matter, especially given the serious intent of his work.

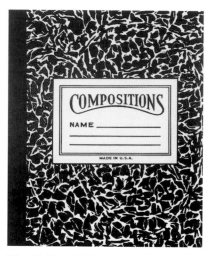

Fig. 21. Roy Lichtenstein, *Composition I*, 1964.

The utter charm of *57 Penguins* extends even to the manner by which the piece was acquired by the Museum für Moderne Kunst in Frankfurt.[25] Lacking the necessary funds to acquire the sculpture, the museum's director, Jean-Christophe Ammann, and a Frankfurt businessman and avid collector of Balkenhol's work, Horst Schmitter, published an advertisement in the *Frankfurter Allgemeine Zeitung*, which quickly yielded individual sponsors for each of the fifty-seven penguins. The project was a brilliant acquisition and a public relations coup for the new museum. As Ammann recalls: "It was a very exciting time.... Many people, even students, were prepared to make a small contribution for one penguin. When the penguins are put on view, we show them along with a list of donors."[26]

Much of Balkenhol's life and work was focused in Frankfurt at the time, in part because he had close relationships with Ammann and Kasper König. Ammann had organized the exhibition of Balkenhol's work for the Kunsthalle Basel in 1988, and that show was subsequently presented in Frankfurt at Portikus, the gallery of the Städelschule, whose director, König, had included Balkenhol in the "Münster Sculpture Project" in 1987. In 1990–91, Balkenhol was teaching at the Hochschule für Bildende Kunst and working at the studio he had recently established in Edelbach, a village southeast of Frankfurt near Aschaffenburg.

Fig. 22. *Untitled*, n.d.

Facing page:
Figs. 23 and 24. *Untitled*, 1995.

Die Assyrer kämpfen
um ihre Hochkultur
zu retten

..... Vergebens

Overleaf (pp. 48–49):
57 Penguins, 1991, cat. no. 12.

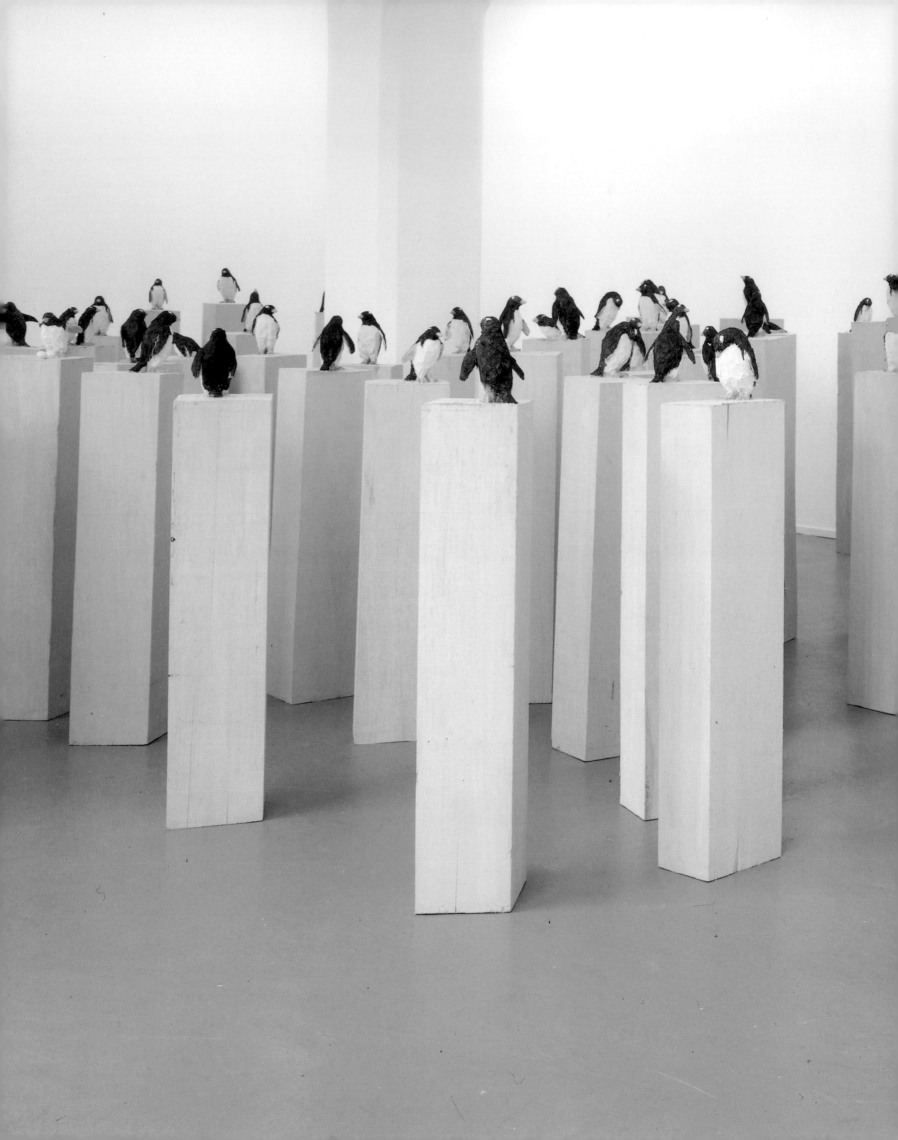

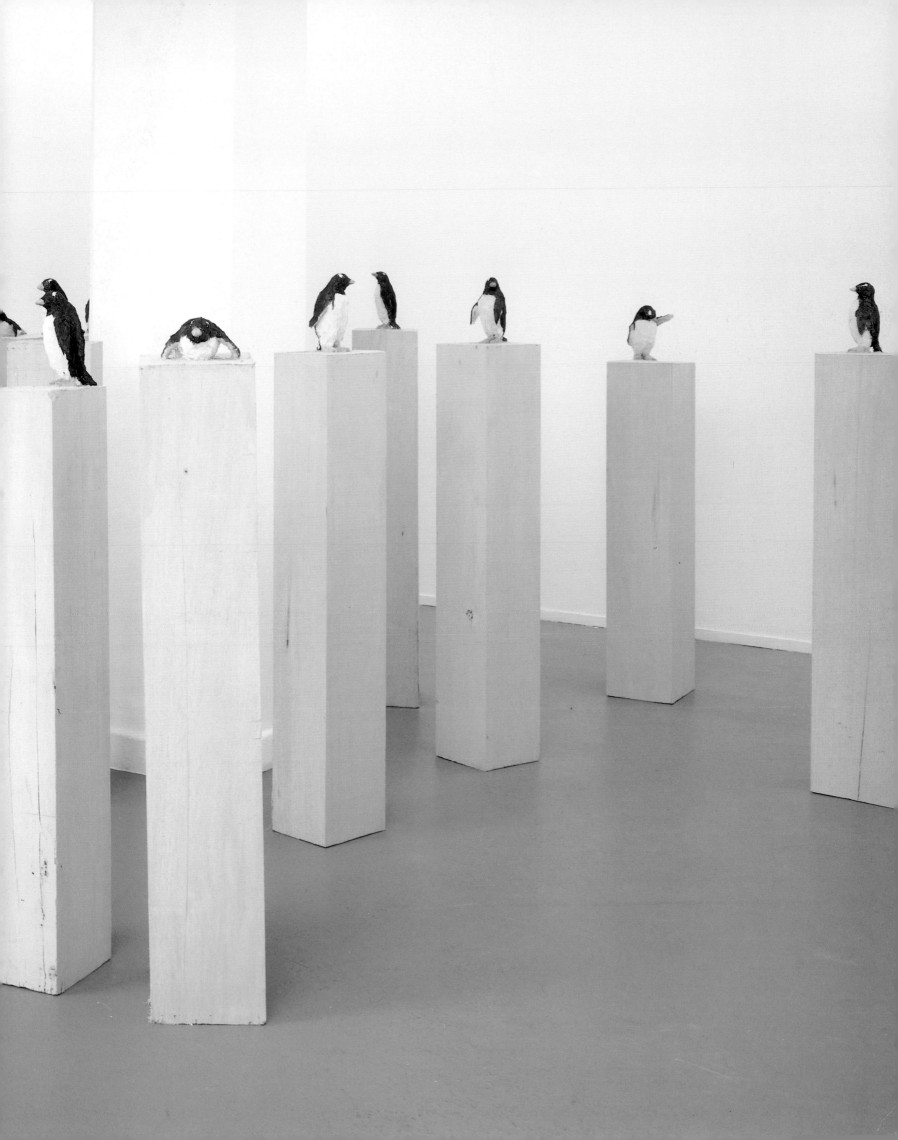

50 In May 1991, Balkenhol installed one of his most interesting outdoor sculptures in the enclosed garden directly behind the Städtische Galerie in Frankfurt.[27] The museum's rear façade is articulated by a series of sculptural niches, which have remained curiously blank through the history of the museum. The largely unutilized and underarticulated setting thus offered Balkenhol a ready-made architectural location ideally suited for his work. The project consisted of three pieces. *Man with Black Pants and White Shirt* and *Woman with Green Dress*, both 1991, were installed in separate stone huts aligned on axis in the garden; a third figure — *Man with Red Shirt and Gray Pants*, also 1991, was mounted above, in a blank niche on the rear façade of the museum (fig. 26).[28] The grouping marked a change in Balkenhol's work, for although he had often arranged figures together, this was perhaps the first instance in which they governed so large a space and so clearly implied a narrative. The two earthbound figures are imprisoned quite literally in their stone cells, and one is visible only through narrow slot-like windows. Mounted on the façade high above, the third figure overlooks the scene with characteristic detachment, its placement recalling the work of Renaissance sculptors in Florence, and its relationship to the imprisoned figures below inevitably suggesting a guard in a watchtower.

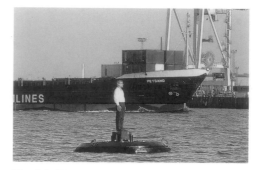

Fig. 25. *Man on Buoy*, 1993, Hamburg.

The combination of prominent works regularly on view in Frankfurt at the time — the Museum für Moderne Kunst included *57 Penguins* in its inaugural presentation in 1991 — offered the young artist a tremendous amount of attention. Early the next year he sited *Standing Figure on Buoy* in the Thames and *Head of a Man* on Blackfriars Bridge for the aforementioned "Doubletake."[29] That highly noted installation led in 1993–94 to similar commissions to place figures in or around bodies of water in Amiens (fig. 27), Dordrecht, Hamburg (fig. 25), and Lisbon.

In his recent work, both indoor and outdoor, Balkenhol has pursued a fascinating dialogue with historical tradition. If the Frankfurt ensemble found him referring to the architectural sculpture of the Italian Renaissance, Balkenhol has also come to reassess the iconography of his work as well. While preparing his Amiens installation, for example, he studied the façade of the cathedral there, and above the west portal he saw thirteenth-century sculptures of martyred saints. Among them are

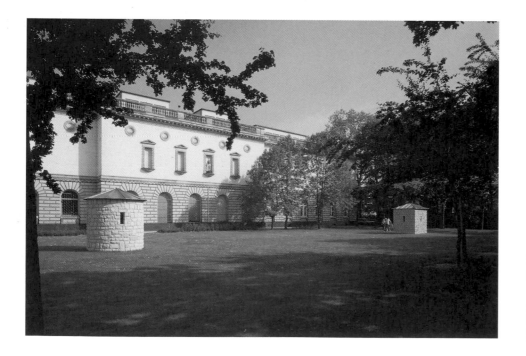

Fig. 26. Städtische Galerie, Städelgarten installation, 1991, Frankfurt.

Facing page:
Fig. 27. *Man with Red Shirt and Gray Pants*, 1993, Amiens.

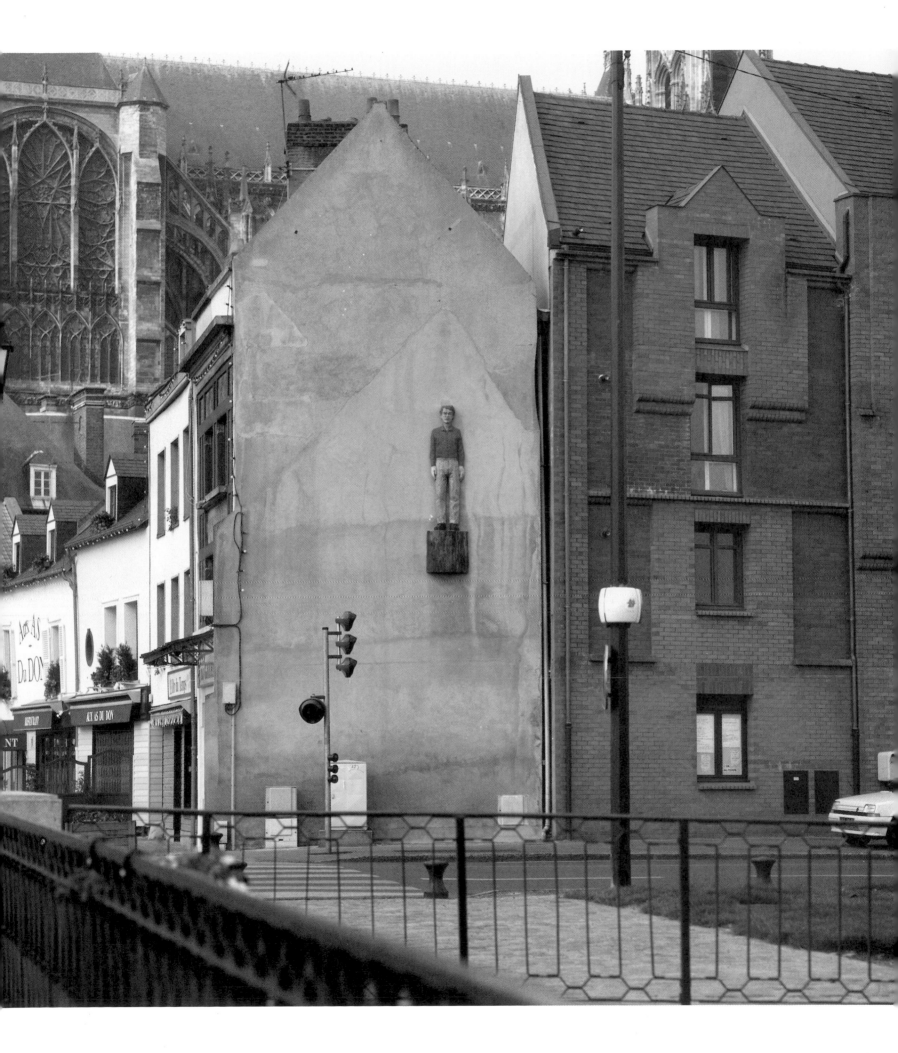

Fig. 28. *Untitled*, 1993.

two figures, Aceolus and Acius, who hold their severed heads in their hands
(fig. 29).[30] The following year, Balkenhol took the subject into the studio and
prepared *Man with Head under His Arm* (illus., p. 22). Similarly, in preparing three
pieces for the Dutch seaport city of Dordrecht in 1993, Balkenhol playfully proposed
a huge monument to a seaman (fig. 28), at once recalling the Colossus of Rhodes and
the more recent proposals by Oldenburg.

 The other direction that Balkenhol has begun to explore in some detail is
narrative. While he had once explicitly rejected that idea, the Frankfurt commission,
with its implicit relationship between the guard above and the imprisoned figures
below, led Balkenhol increasingly to consider the relationships between his figures.
As he noted in a 1994 interview:

*I used to attempt to eliminate any narrative aspect whatsoever from my works.
Today I still refuse narration when I voluntarily omit gesture and expression, but
sometimes, and increasingly perhaps, I take an interest in the problems connected with
it, and in the question of the subject.*[31]

While Balkenhol has only recently concentrated on traditional forms of content, two
pieces mentioned above — *Small Man on a Giraffe* and *Small Man on a Snail*
(illus., pp. 53, 56) — involve the relationship between a diminutive man clothed in
white shirt and black pants and an unlikely animal. In 1994, Balkenhol returned to
that subject, his male figures now paired with salamanders, dolphins, and zebras.
For an exhibition at the Neue Nationalgalerie, Berlin, also in 1994, Balkenhol
prepared a series of "blackboard" drawings — oil stick on wood panels painted black
— in which he depicted individual men interacting with different animals (illus.,
back endleaves). Characteristically, Balkenhol calls upon art history, in this case
demonumentalizing the heroic tradition of the classical calf-bearer, and, more
recently and perhaps more relevantly, Picasso's six-and-a-half-feet-high

Fig. 29. Amiens Cathedral.

Essay continues on page 63.

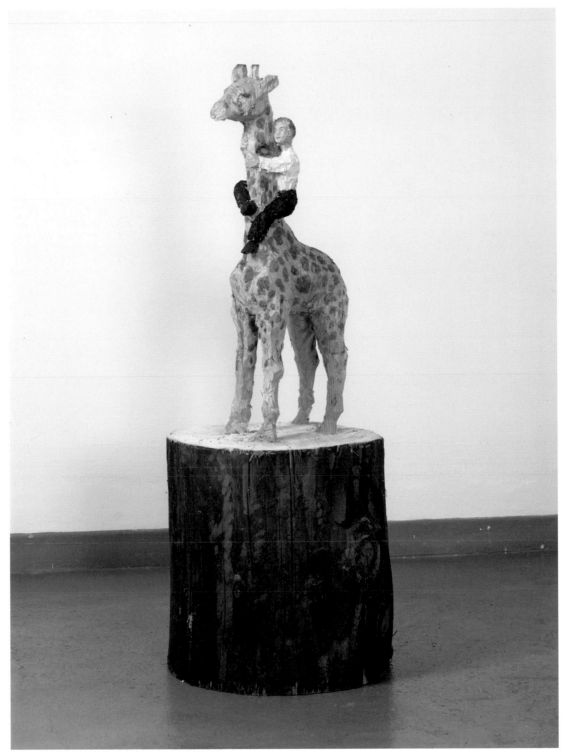

Small Man on a Giraffe, 1990, cat. no. 10.

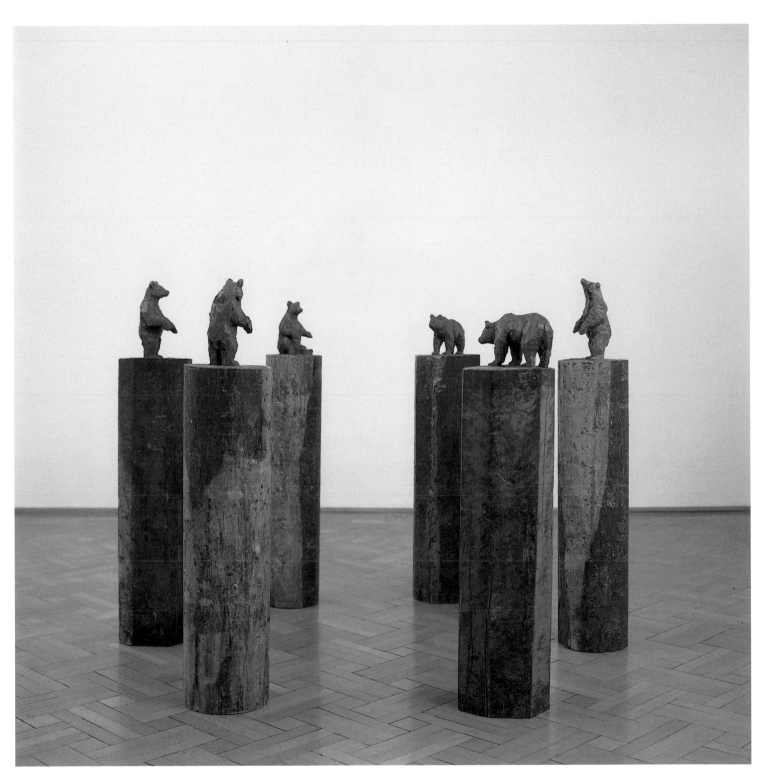

Six Bears, 1991, cat. no. 16.

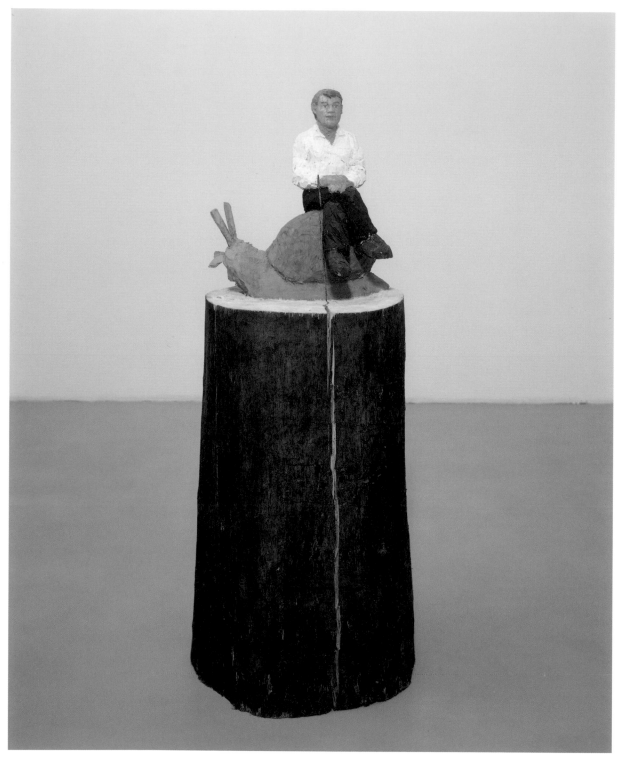

Small Man on a Snail, 1991, cat. no. 17.

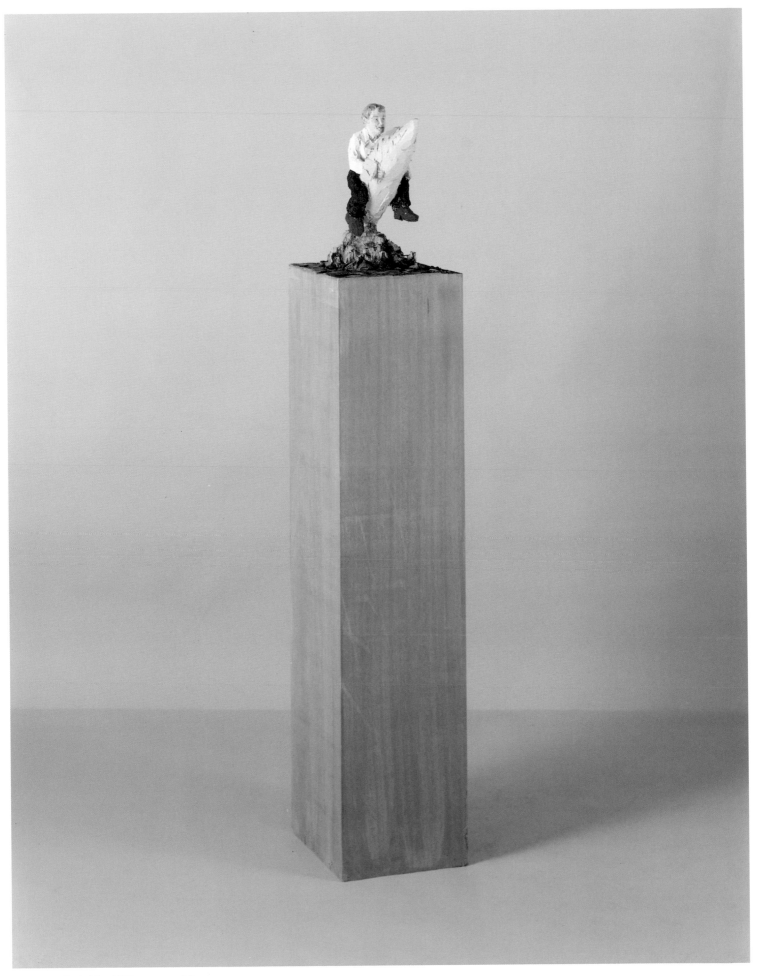

Man on a Dolphin, 1993, cat. no. 20.

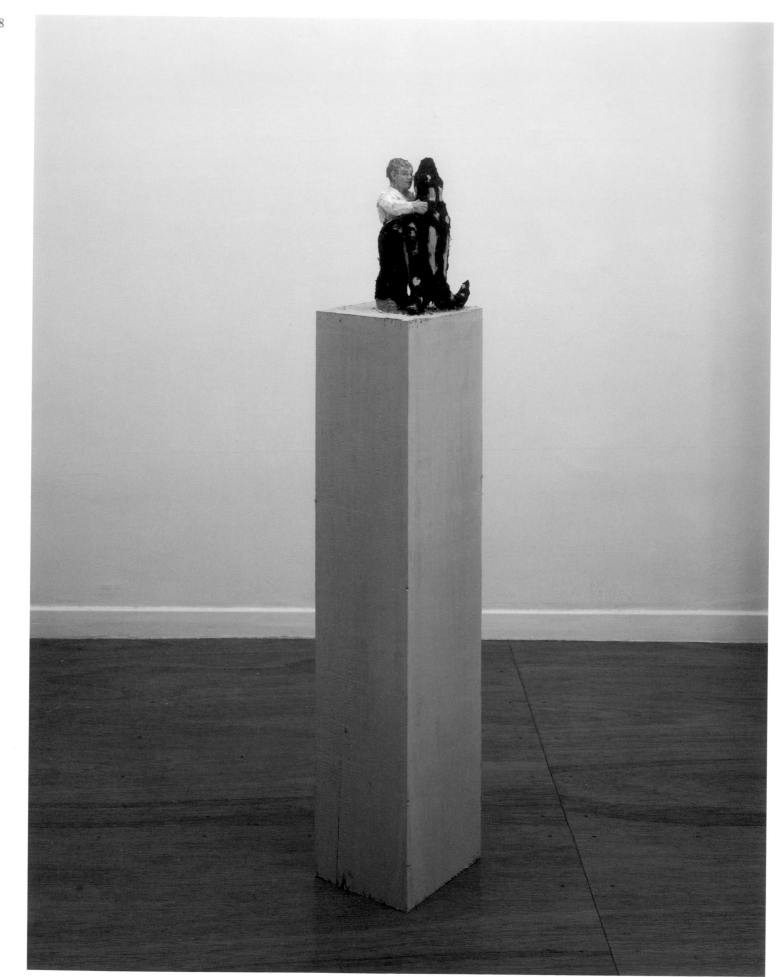

Man with Salamander, 1994, cat. no. 26.

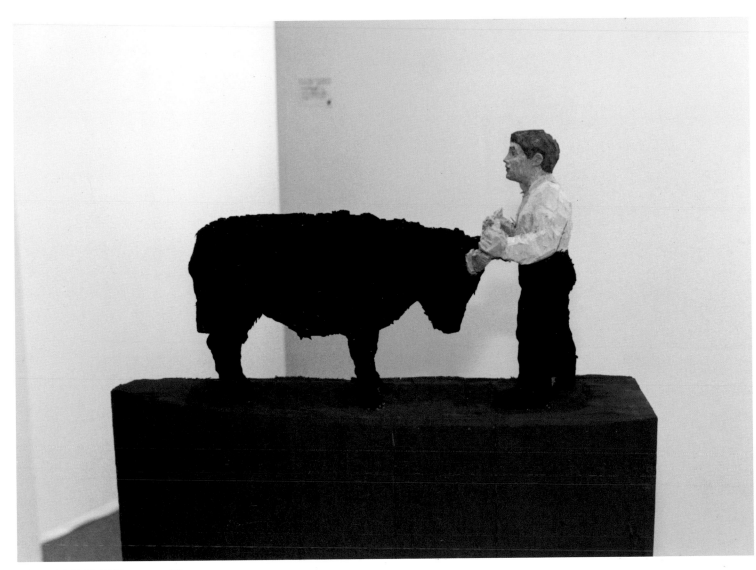

Man with Bull, 1994, cat. no. 23.

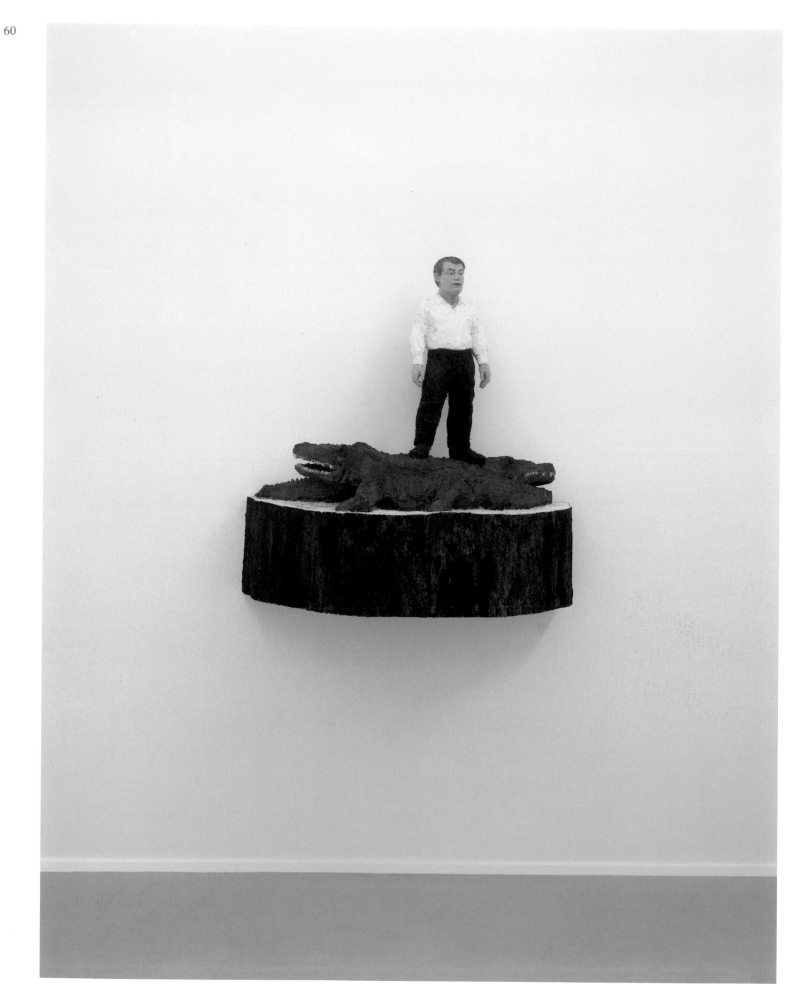

Small Man with Two Crocodiles, 1994, cat. no. 29.

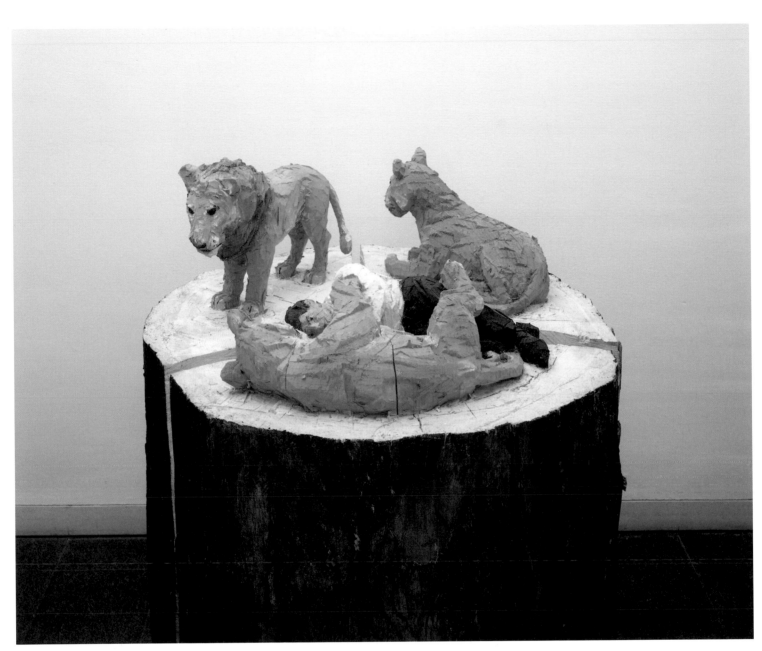

Man with Lions, 1994, cat. no. 25.

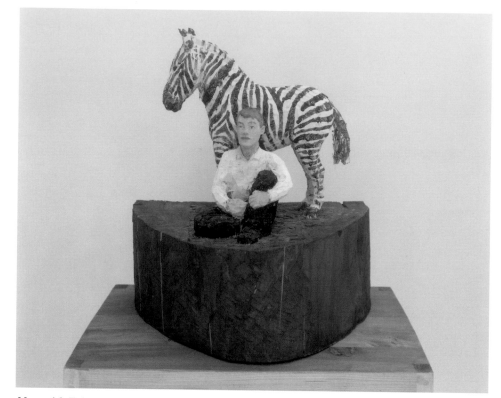

Man with Zebra, 1994, cat. no. 27.

Man with a Sheep (fig. 30), a reproduction of which hangs on the artist's studio wall. While sculptors throughout history have shown man dominating animal, Balkenhol has turned the tables, endowing the animal with equal or larger scale and often placing the man in mock perilous predicaments. Balkenhol's ongoing series, which he describes as the "adventures of the small man in white shirt and black pants,"[32] might best be considered a folktale, its narrative treated as the province of humble individuals engaged in lighthearted behavior. Here Balkenhol diverges from the self-conscious seriousness implied in so much contemporary art. He addresses one of the most clichéd subjects of the twentieth century and imbues it with refreshing innocence and humor.

Having said this, it must be noted that Balkenhol has also taken on more obviously consequential subjects when the opportunity has arisen. Selected to represent Germany in "Africus," the first Johannesburg Biennale, held in the spring of 1995, Balkenhol produced *Global Couple* (fig. 31), figures of a black man and a white woman each surmounting half-globes high atop the entrance to the exhibition pavilion. A remarkable reinvention of his guardian figures of the mid-1980s, Balkenhol's most recent public sculpture addresses South Africa's legacy of apartheid at precisely the moment when that tragic country re-enters the international community from self-imposed exile. As he ranges from the mundane to the political, and from the diminutive to the monumental, Balkenhol, like Picasso before him, demonstrates the continuing and seemingly limitless potential of figurative sculpture in the late twentieth century.

In assessing Balkenhol's work to date, and the response it has engendered among artists and the public, it would be worthwhile to return to a statement the sculptor made in a 1988 interview:

> *Why I'm doing figural work again is also partly a reaction to the rather dispassionate, rational and very insensuous art of the 70s. . . . It was as if art didn't or wouldn't illustrate anything, wouldn't relate anymore to what was happening externally, but only reflected its own principles and methods and in the end only illustrated itself.*[33]

One must recall that when Balkenhol was a student in Hamburg, around 1980, the Minimalist and Conceptualist movements were well established in Europe and had flourished for nearly two decades. Yet, to Balkenhol, the willful exorcism of imagery and subjective content had caused those movements to fall into an academic malaise, complete with empty theorizing and merely elegant design. He sought an art that would instead be accessible to a broad public, and the figure obviously offered such possibilities. In the process, however, Balkenhol was caught in a buzz saw of critical response among artists of his own generation and the art world at large. Indeed, he was making sculpture that bore little relation to recent figurative work — the idealistic, pathos-ridden plasters of George Segal on the one hand and the emblematic painted wood sculptures of Georg Baselitz on the other.[34] Younger European artists had largely repudiated the figure as a subject (with the occasional exception of its representation in videotape and photography), while in North America, references to the "figure" in art have been dominated by issues pertaining to "the body," indicative of the recent trend toward expressions of social and political outrage.[35] In a word, Balkenhol has avoided the overwhelmingly ironic stance that has lately prevailed in representations of the figure throughout Europe and in the politicized body images of North American artists since the 1980s. Balkenhol's rejection of Neo-Conceptualism consigned him to an odd place well outside the mainstream art

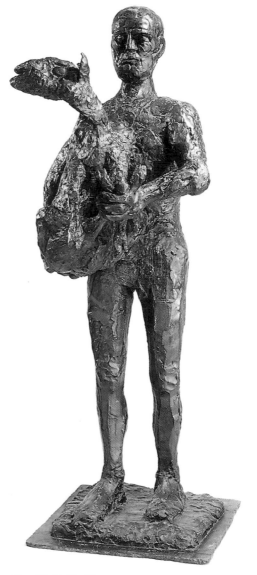

Fig. 30. Pablo Picasso,
Man with a Sheep, 1943–44.

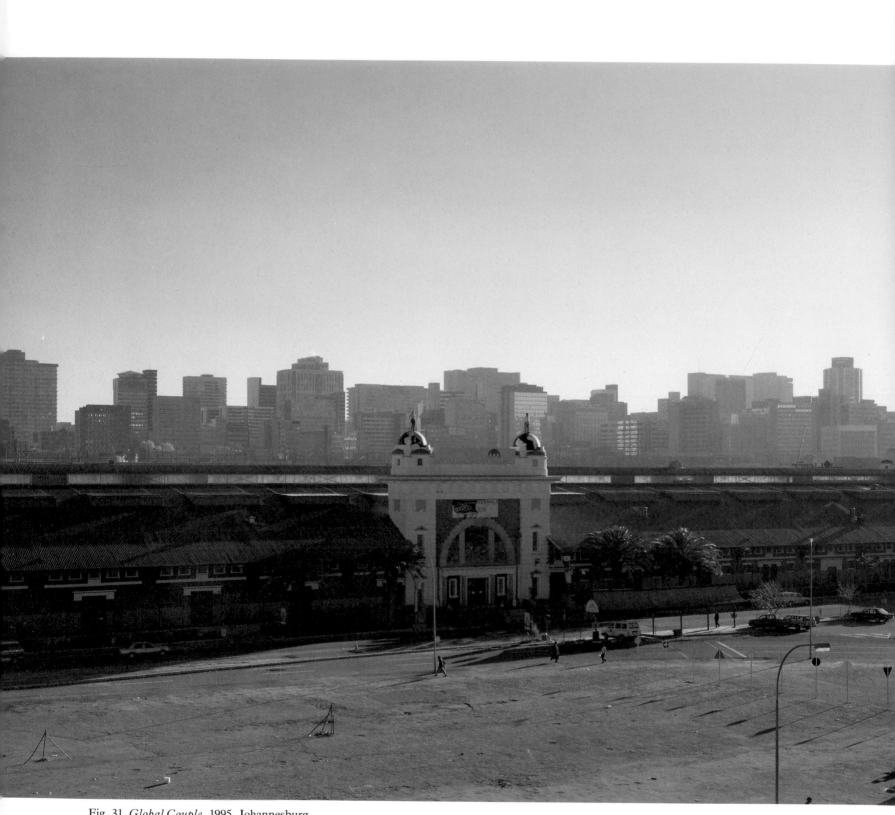

Fig. 31. *Global Couple*, 1995, Johannesburg.

world. While the public appeal of Balkenhol's sculpture has been apparent from the outset of his career, the seemingly conservative aspects of his practice — his craft, his reliance on the figure, and his avoidance of postmodern issues surrounding originality and representation — ironically have made him an iconoclast in certain contemporary art circles.

For all these reasons, Balkenhol's work has elicited more than its share of comment from other artists. Perhaps the most stridently critical has been Thomas Schütte, the multifaceted young German sculptor who, like Balkenhol, exhibited in the "Münster Sculpture Project" in 1987. While Schütte has made figurative work since the early 1980s, his course has been characteristically postmodern, for the figure is but one of many subjects he employs, and he has realized his sculpture in materials ranging from clay to cardboard. During the summer of 1992, Schütte participated in "Documenta 9," where he exhibited *The Strangers* (fig. 32), a group of figures resembling chessmen mounted above a colonnaded portico on the Friedrichsplatz in Kassel. The apparent similarity between the figurative aspect of Schütte's work and Balkenhol's own led to a formal conversation between the artists in September 1992, which was published in Balkenhol's Rotterdam catalog later that year.[36] There, Schütte's indictment of Balkenhol's enterprise was all-encompassing: clearly Balkenhol represents to Schütte everything that postmodernists reject. His criticism ranged from Balkenhol's perceived lack of intellectual content to the seeming repetitiveness of Balkenhol's work ("If you say something three times, it must be enough. And as for diffusion, we have [an] excellent shipment system and photography. Today, you don't have to tell the same joke for thirty years").[37]

What Schütte's critique ignored, however, is the radically changed climate of our time. In contrast to artists working in the United States, where the greater commercial vigor of the art world has fostered a thirst for constant change and with it a general abhorrence of critical theory, European artists have adhered, often rigidly, to ideological battle lines regarding the criteria for advanced art. In the political and cultural stasis of the late Cold War — in the twilight of ideology, in culture as well as politics — European artists and commentators could debate the theoretical merits of various artists and movements. With the events of 1989, however, and the evaporation of coherent political ideologies in the West, arguments pertaining to advanced positions in art have lost their currency and relevance.

This was precisely Jeff Wall's point when he praised Balkenhol for finding a way to reinvent sculpture and locate in the figure the "potential for a spontaneous form or recognition of meaning."[38] Taking up the theme in the 1992 symposium in Rotterdam, "The Body Is Present," which was formally devoted to the representation of the body in contemporary art but that concentrated on Balkenhol's work, the English photographer Craigie Horsefield eloquently made the case for a new approach to the figure.

What I'm saying is that we are actually expressing ideas which are appropriate to today in a form which is, by [Balkenhol's] definition of this avant-gardist convention, extremely old-fashioned. But of course we may express the most complex and prescient ideas with it, that is, ideas that are appropriate to our time. . . . In the sculptures that Stephan Balkenhol makes and the photographs that I make, we may use all kinds of language which are open to us, but the meaning is most specifically about the present. Of course that makes it difficult because we're used to looking for avant-garde signs. With the loss of progress, we lose the avant-garde. What we do face is a world in which we are forced back on meaning, on subject, on content as the new thing, and that is more difficult, more problematic."[39]

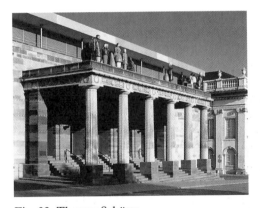

Fig. 32. Thomas Schütte, *The Strangers*, 1992, Kassel.

Horsefield believes that we must move beyond simpleminded identifications of work as progressive or conservative based on issues of representation and ideology. Content and the role of art in a world suddenly and frighteningly in flux are questions that must be addressed if art is to regain its meaning for a broader audience. Arguably, the most compelling developments in art since the late 1980s had nothing whatever to do with the latest conceptual or aesthetic fashion. At a time when Chinese art students were earnestly erecting monuments to liberty (fig. 33), when Russians and Eastern Europeans were unceremoniously leveling countless monuments to Marx and Lenin (fig. 34), and when American veterans insisted that Maya Lin's starkly geometric 1982 Vietnam Veterans Memorial be followed by two figurative monuments to participants in that war, an art based not in critical theory but rather "forced back on meaning, on subject, on content" shifted the focus toward a renewed public purpose.[40] That the art world scarcely took note of the passion underlying these public dramas is, it seems, a sure sign of the tacit contempt with which many in the art world hold their audience and the public generally.[41]

Remaking sculpture in a public image, Stephan Balkenhol has surely chosen a difficult task. He invites ridicule from those who see his endeavor as traditional, historicist, and pandering to his viewers. Yet, at this still-early stage in his career, one should not make too strong a case for the public content of his work. While Balkenhol has resuscitated figurative sculpture from a burdensome tradition and achieved a distinctive approach, he has done so by jettisoning precisely the type of expressive content that has come to characterize figurative sculpture in wood. As his piece for the Johannesburg Biennale suggests, he will infuse his work with ideas and content a when the context suggests it. Narrative may be the crucial next step in the development of Balkenhol's work, for the content of his forthcoming sculpture will likely be its measure.

With a knowing innocence that is a welcome tonic for contemporary art, Balkenhol moves ahead. His art, it would seem, belongs not to those that covet it but rather to those who simply encounter it. In Europe and America, continents now teeming with men and women from other places and cultures, the significance of Balkenhol's sculpture may reside in the very anonymity of his men and women. Despite their unobtrusiveness, they remain insistently present.

Fig. 33. Replica, Statue of Liberty, Tianamen Square, Beijing, China, May 1989.

1 Robin Stringer, "Why Can't You Dummies Just Let Me Be Alone?," *Evening Standard* (London), 28 February 1992; and Richard Cork, "Do You See What I See?," *Times* (London), 28. February 1992, Life and Times section. Balkenhol made two sculptures for the group exhibition "Doubletake: Collective Memory and Current Art," London, Hayward Gallery, 1992. The aforementioned *Standing Figure on Buoy*, 1992, was installed in the Thames, and *Head of a Man*, 1992, on Blackfriars Bridge.
2 The exhibition "Stephan Balkenhol: Über Menschen und Skulpturen/About Men and Sculpture," the artist's largest to date, was organized by the Witte de With Center for Contemporary Art, Rotterdam, 1992–93.
3 Biographical information has been collected in a series of conversations between the author and the artist that took place on April 9, 1992, in Edelbach, Germany; November 10, 1992, in Washington, D.C.; June 5, 1993, in Karlsruhe, Germany; and June 25, 1994, in Meisenthal, France. Additional information derives from an interview with the artist by Stephanie Jacoby, August 11, 1994, in Washington, D.C.
4 Conversation with the author, November 10, 1992.
5 Conversation with the author, June 25, 1994.
6 Conversation with the author, June 5, 1993.

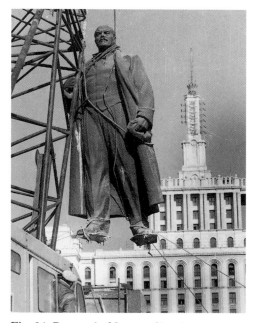

Fig. 34. Removal of Statue of Lenin, Bucharest, Romania, March 1990.

7 Quoted in *Possible Worlds: Sculpture from Europe* (London: Institute of Contemporary Arts and Serpentine Gallery, 1991), 29. In 1985, Rückriem contributed a brief, untitled essay on Balkenhol's work to *Stephan Balkenhol: Skulpturen* (Darmstadt: Mathilden-höhe), n.p. The publication also included a recent conversation between the two artists. That interview was also reprinted in *Stephan Balkenhol: Über Menschen und Skulpturen/ About Men and Sculpture* (Rotterdam: Edition Cantz, 1992), 16–19.

8 Quoted in *About Men and Sculpture,* 12.

9 See Balkenhol's comments in *Possible Worlds,* 27. The artist's own photographs of these early works are illustrated in *About Men and Sculpture,* 20–25.

10 See documentary photographs of *Man* and *Woman* in *About Men and Sculpture,* 12–15.

11 Quoted in *Binationale: German Art of the Late 80's* (Cologne: DuMont, 1988), 70.

12 Quoted in ibid., 69.

13 Quoted in *Possible Worlds,* 27.

14 Quoted in ibid., 28.

15 Conversation with the author, June 25, 1994.

16 Quoted in *Binationale,* 68.

17 Quoted in "The Body Is Present," a paper presented at a symposium held December 13, 1992, on the occasion of Balkenhol's exhibition in Rotterdam and published by the Witte de With Center for Contemporary Art as *The Lectures* (1993), 92.

18 Quoted in *Kunst im öffentlichen Raum: Anstösse der 80er Jahre* (Cologne: DuMont, 1989), 260. Translation by Stephanie Jacoby.

19 Jean-Christophe Ammann, *Stephan Balkenhol* (Basel: Kunsthalle Basel, 1988), n.p.

20 Conversation with the author, November 10, 1992.

21 See Klaus Bussmann and Kasper König, *Skulptur Projekte in Münster* (Cologne: DuMont, 1987).

22 Jeff Wall, "Bezugspunkte im Werk von Stephan Balkenhol," in *Stephan Balkenhol* (Kunsthalle Basel, 1988), n.p. The essay is reprinted in the original English in *About Men and Sculpture,* 98–102.

23 Ibid.

24 Chevrier, Jean-François, and James Lingwood, "Specific Pictures," in *Another Objectivity* (London: Institute of Contemporary Art, 1988), n.p.

25 See Jean-Christophe Ammann, "Stephan Balkenhol: 57 Penguins," *Parkett* 36 (1993): 66–69.

26 Ibid., 68.

27 Gallwitz, Klaus, and Ursula Grzechca-Mohr, *Stephan Balkenhol im Städelgarten* (Frankfurt: Städtische Galerie, 1991).

28 An additional, fourth figure was subsequently added to a niche located on the east façade of the building.

29 See *Doubletake: Collective Memory and Current Art,* 256.

30 I am indebted to Jeffrey C. Anderson of George Washington University, Washington, D.C., and to Stephanie Jacoby for their suggestions on this point.

31 Quoted in *Stephan Balkenhol* (Rochechouart: Musée Départmental de Rochechouart, 1994), 13, 15.

32 Conversation with the author, June 25, 1994.

33 Quoted in *Binationale,* 68.

34 See Neal Benezra, "Stephan Balkenhol: The Figure as Witness," *Parkett* 36 (1993): 38.

35 Two of numerous North American exhibitions devoted to the body are Boston, Museum of Fine Arts, "Figuring the Body," 1989; and Chicago, Renaissance Society of the University of Chicago, "The Body," 1991.

36 See "Conversation Between Stephan Balkenhol and Thomas Schütte" in *About Men and Sculpture,* 72–79.

37 Schütte quoted in ibid., 75; translation, English supplement, 9.

38 Wall quoted in *Stephan Balkenhol* (Kunsthalle Basel, 1988), n.p.

39 Horsefield quoted in *The Lectures,* 93.

40 See Elizabeth Hess, "A Tale of Two Monuments," *Art in America* 71 (April 1983): 121–26; "Moscow's Monuments Come Tumbling Down," *Art in America* 79 (October 1991): 37; and Roxanne Roberts, "Honoring the Women," *Washington Post* (2 November 1993), 1, 8.

41 See Adam Gopnik, "The Death of an Audience," *New Yorker* (5 October 1992): 141–46.

Unless otherwise noted, all sculptures are carved wood painted with pigments and acrylic emulsion. Dimensions of sculptures include the artist's bases; height precedes width and depth.

1, illus. p. 11
Relief, 1983
beech, 78 3/4 x 75 5/8 x 11 in. (200 x 192 x 28 cm)
Ludwig Forum für Internationale Kunst, Aachen, Germany

2, illus. p. 14
Large Man with Green Shirt, 1984
poplar, height 92 1/2 in. (235 cm)
Collection Hans Jochen and Sabine Waitz, Hamburg

3, illus. p. 15
Large Man with Pink Shirt, 1984
poplar, height 91 3/8 in. (232 cm)
Collection Reiner Stadler and Maja Stadler-Euler, Hamburg

4, illus., frontispiece
Lion, 1984
poplar, length 70 7/8 in. (180 cm)
Private collection, Switzerland

5, illus., back cover and p. 13
Three Figures, 1985
beech, 78 3/4 x 78 3/4 x 11 7/8 in. (200 x 200 x 30 cm)
Collection Elisabeth Ruhland, Düsseldorf

6, illus. p. 8
Man with Black Pants, 1987
beech, 90 3/8 x 36 1/4 x 34 3/4 in. (229.5 x 92 x 88.2 cm)
Hirshhorn Museum and Sculpture Garden, Smithsonian Institution, Washington, D.C., 1989 (89.26)

7, illus. pp. 16–17
Relief Heads 1–6, 1988
poplar, each 27 5/8 x 21 3/4 in. (70 x 55 cm)
Private collection, Berg, Germany; courtesy Galerie von Braunbehrens, Munich

8, illus. p. 33
Large Couple (Heads of a Man and a Woman), 1990
wawa, each 47 1/4 x 39 3/8 x 39 3/8 in. (120 x 100 x 100 cm)
The Montreal Museum of Fine Arts; Purchase, Camil Tremblay Estate

9, illus. p. 19
Seated Man, 1990
poplar, height 61 7/8 in. (157 cm)
Collection Horst + Vivien Schmitter, Hamburg

10, illus. p. 53
Small Man on a Giraffe, 1990
conifer, 58 1/4 x 20 1/2 in. (148 x 52 cm)
Galerie von Braunbehrens, Munich

11, illus. p. 18
Small Relief (Man), 1990
poplar, 9 7/16 x 9 7/16 x 1 1/2 in. (24 x 24 x 4 cm)
Private collection, Otegem, Belgium;
courtesy Deweer Art Gallery, Otegem

12, illus. pp. 48–49
57 Penguins, 1991
wawa, each approx. 59 1/8 x 13 3/4 x 13 3/4 in. (150 x 35 x 35 cm)
Museum für Moderne Kunst, Frankfurt

13, illus. p. 20
Head on a Column (Man), 1991
wawa, height 59 1/8 in. (150 cm)
Collection Christoph Graf Hardenberg, Hamburg

14, illus. p. 21
Head on a Column (Woman), 1991
wawa, height 67 7/8 in. (157 cm)
Collection Dr. Dammann, Hamburg

15, illus. p. 34
Sculpture Cross, 1991
poplar, 61 7/8 x 23 5/8 x 23 5/8 in. (157 x 60 x 60 cm)
Jedermann Collection, N.A.
(Shown in Washington, D.C., only)

16, illus. p. 55
Six Bears, 1991
unpainted lignum vitae, each, height 57 1/8 in. (145 cm)
Galerie Löhrl, Mönchengladbach, Germany

17, illus. p. 56
Small Man on a Snail, 1991
conifer, height 61 7/8 in. (157 cm)
Collection H. + H. Quadflieg, Düsseldorf

18, illus. p. 35
Double-Identity Figure, 1992
poplar and oak, 93 1/2 x 86 1/2 x 36 7/8 in. (238 x 220 x 93 cm)
Collection Mr. & Mrs. Harold E. Rayburn, Davenport, Iowa

19, illus. p. 39
Man in Black Trunks, 1993
sugarpine, 85 7/8 x 26 3/4 x 20 1/8 in. (218 x 68 x 51 cm)
The Neuberger & Berman Collection, New York

20, illus. p. 57
Man on a Dolphin, 1993
wawa, 60 5/8 x 10 7/8 x 13 7/8 in. (154 x 27.5 x 30.5 cm)
Kunstverein Bremerhaven v. 1886 e.V., Germany

21, illus. pp. 36–37
Tondi (Head of a Woman/Head of a Man), 1993
poplar
each, diameter 61 7/8 in. (157 cm)
Collection Horst + Vivien Schmitter, Hamburg

22, illus. p. 38
Woman in Green Bathing Suit, 1993
sugarpine, 85 7/8 x 26 3/4 x 20 1/8 in. (218 x 68 x 51 cm)
Collection George P. Mills, New York

23, illus. p. 59
Man with Bull, 1994
wawa, 57 7/8 x 22 7/8 in. (147 x 58 cm)
Collection Michael and Tini Rosenblat, Hamburg

24, illus. p. 22
Man with Head under His Arm, 1994
cedar, 97 1/4 x 27 5/8 x 21 5/8 in. (247 x 70 x 55 cm)
Musée Départemental d'Art Contemporain de Rochechouart, France

25, illus. p. 61
Man with Lions, 1994
Lebanon cedar, height 59 1/8 in. (150 cm)
Collection Horst + Vivien Schmitter, Hamburg

26, illus. p. 58
Man with Salamander, 1994
wawa, 60 1/4 x 9 1/2 x 11 in. (153 x 24 x 28 cm)
Collection Gabriele Fehm-Wolfsdorf and Lorenz H. Fehm,
Lübeck, Germany

27, illus. p. 62
Man with Zebra, 1994
limewood, 61 1/8 x 23 1/4 x 15 in. (155 x 59 x 38 cm)
Collection L. Beunen-Akinci, Amsterdam

28, illus., portfolio (back)
Sixteen Blackboard Drawings, 1994
oil stick on wood
each 73 x 51 3/8 in. (186 x 130.5 cm)

a. *Camel*
Galerie Löhrl, Mönchengladbach, Germany

b. *Cat*
Mai 36 Galerie, Zurich

c. *Cow*
Galerie Löhrl, Mönchengladbach, Germany

d. *Dog*
Galerie Löhrl, Mönchengladbach, Germany

e. *Dolphin*
Art Consulting Siebenhaar, Frankfurt

f. *Donkey*
Galerie Löhrl, Mönchengladbach, Germany

g. *Elephants*
Galerie Löhrl, Mönchengladbach, Germany

h. *Giraffe*
Art Consulting Siebenhaar, Frankfurt

i. *Horse*
Collection Wilhelm Sandmann, Hannover

j. *Lion*
Collection Herbert Quadflieg, Düsseldorf

k. *Lizard*
Galerie Löhrl, Mönchengladbach, Germany

l. *Ostrich*
Collection Dr. Udo von Klot-Heydenfeldt, Kronberg, Germany

m. *Parrot*
Mai 36 Galerie, Zurich

n. *Pig*
Mai 36 Galerie, Zurich

o. *Rhinoceros*
Mai 36 Galerie, Zurich

p. *Zebra*
Galerie Löhrl, Mönchengladbach, Germany

29, illus. p. 60
Small Man with Two Crocodiles, 1994
cedar, 39 3/8 x 36 5/8 x 17 3/4 in. (100 x 93 x 45 cm)
Private collection, Munich

30, illus., cover and p. 6
Three Hybrids, 1995
cedar, each approx. 47 3/4 x 19 3/4 x 13 1/2 in
(121.3 x 50.2 x 34.3 cm)
Barbara Gladstone Gallery, New York

31, illus. pp. 40–41
Volume Reliefs I and II (Male and Female), 1995
poplar, (male) 87 1/2 x 46 1/4 in. (222.3 x 117.5 cm);
(female) 94 1/2 x 44 1/4 x 44 1/4 in. (240 x 112.4 cm)
Barbara Gladstone Gallery, New York

Fig. 35. *Untitled*, 1982.

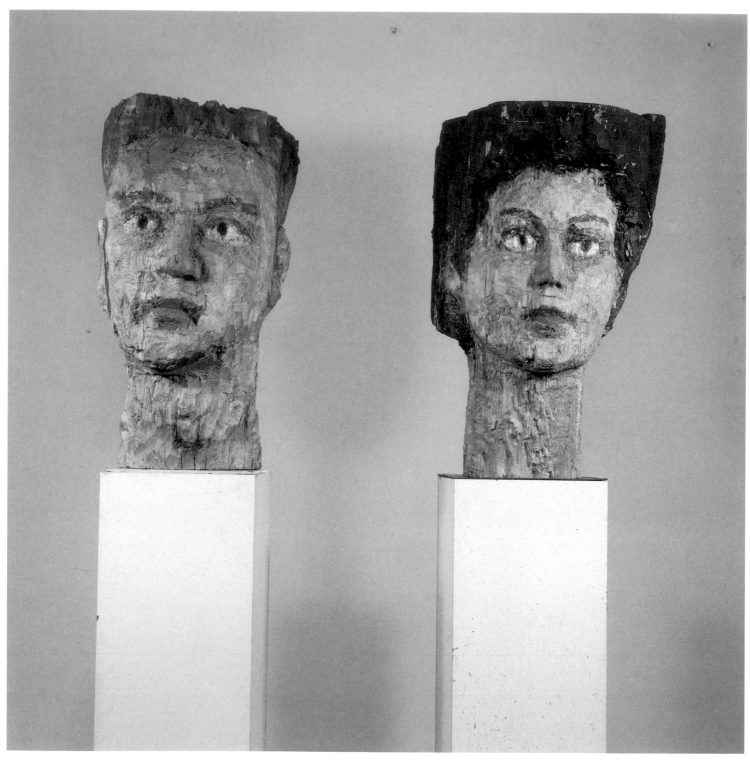

Fig. 36. *Male and Female Heads,* 1982.

Documentation

Stephanie Jacoby

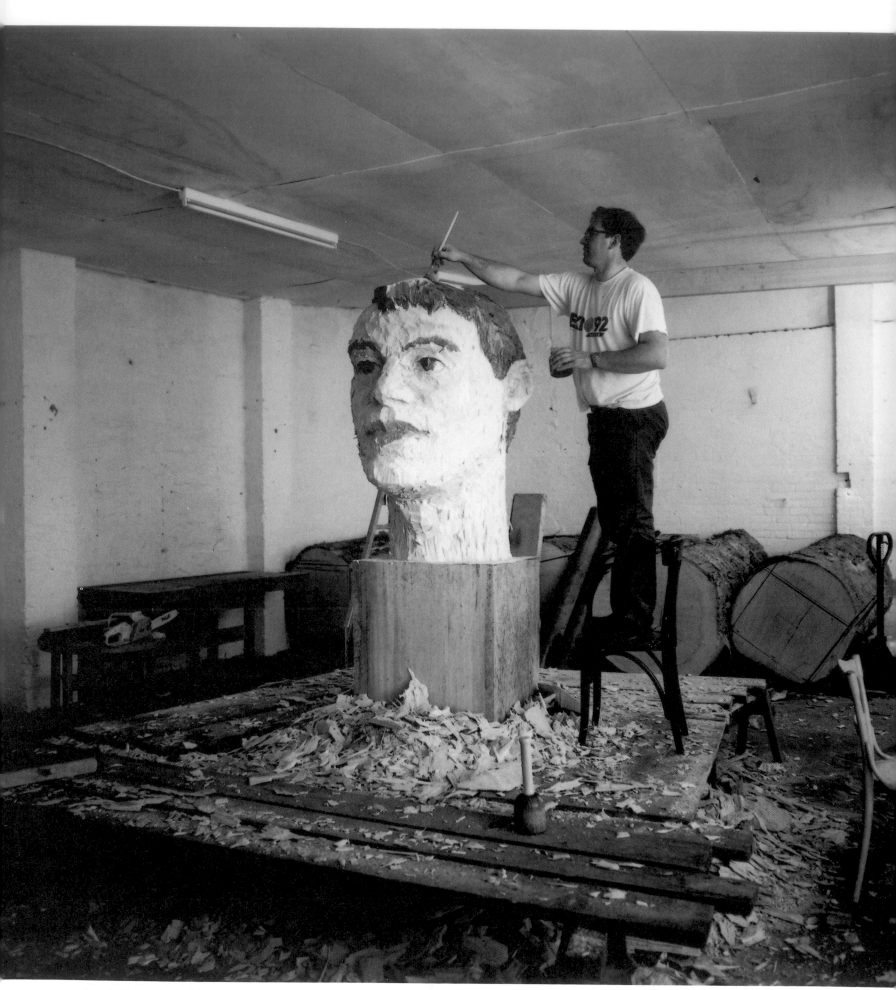

Fig. 37. Balkenhol in his studio, Hamburg-St. Pauli, 1991.

1957

The youngest of four sons, Stephan Balkenhol was born on February 10, 1957, in Fritzlar, West Germany, where he lived the first six years of his life. His father, Herrmann (died 1978), was a high-school teacher who taught history and German. His mother, Paula (died 1988), was a housewife.

1963

The Balkenhol family moved to Luxembourg, where Stephan became fluent in French.

1968

The family relocated to Kassel, the Hessian city that every five years hosts "Documenta," an international exhibition of contemporary art. Here Balkenhol spent his teenage years.

1971–72

Balkenhol began experimenting with sculpture, making collages and assemblages in the Dadaist tradition. In 1972 one of Balkenhol's older brothers, an art student at the university in Kassel, obtained a job selling catalogs and admissions at "Documenta 5." Balkenhol thus gained free access to the galleries and visited them frequently. He was particularly intrigued with a pavilion titled "Realism," an international survey of current works by artists producing Pop and Photo-Realist painting and sculpture. Balkenhol, who by that time had already decided to become an artist, was especially influenced by the figurative work.

1973–76

From age sixteen to nineteen, Balkenhol carved several wood sculptures of human heads.

1976–82

In 1976, Balkenhol graduated from high school and moved to Hamburg, where he set up a studio in Hamburg-Volksdorf and entered the Hochschule für Bildende Künste. Among its faculty were Nam June Paik, Sigmar Polke, and Ulrich Rückriem. Balkenhol soon became Rückriem's student, and later his studio assistant. In 1980, together with a fellow student, Balkenhol made a series of "frozen" sculptures consisting of frozen fabric that had been cast outdoors in the form of steps, tunnels, and chairs. In 1980–81 the young artist also produced a number of dolomite basins and cubes that recall Rückriem's granite-block sculptures. In the early 1980s, Balkenhol traveled to Copenhagen, London, Munich, Paris, and Rome to study museum collections and public figurative sculpture. He took photographs and made numerous drawings of ancient Greek kouroi and Roman portrait busts. In 1981, Balkenhol produced clay studies of human heads. In the following year he carved *Male and Female Heads*, 1982, and graduated with a master of arts in Art Education.

1983

Working independently, Balkenhol made his first roughly hewn wood sculptures of full-length nude figures, *Man* and *Woman*, 1983. Together with *Male and Female Heads*, 1982, these sculptures were shown in the group exhibition "Impulse 1," organized by Galerie Löhrl, Mönchengladbach, West Germany. Balkenhol also carved his earliest animal sculptures and figures depicted in clothes. He received

a scholarship from the Karl-Schmidt-Rottluff Förderungsstiftung. In the same year, he participated in the art fair "Förderstand ART Cologne," where he exhibited *Male Figure*, *Man with White Shirt and Red Pants*, and *Relief*, all 1983.

1984

As a scholarship recipient, Balkenhol exhibited his first relief sculpture, *Relief*, 1983 (cat. no. 1), together with *Female Head*, 1983, *Man with Nude Torso*, 1984, and *Male Figure*, 1984, in the group show "Die Stipendiaten der Karl-Schmidt-Rottluff Förderungsstiftung" at the Brücke-Museum, West Berlin.

1985

Balkenhol participated in the group show "Die Karl-Schmidt-Rottluff Stipendiaten," held at the Austellungshallen Mathildenhöhe, Darmstadt. Among the works exhibited were his first animal sculptures, *Cow Head*, 1983, and *Lion*, 1984 (cat. no. 4).

1986

The artist made his first major public sculpture, *Rider*, 1986, for "Jenisch-Park Skulptur," an exhibition of outdoor sculpture displayed in the park surrounding the Jenisch House, Hamburg. Balkenhol selected the circular area in front of the house as the site for the nearly life-size equestrian statue installed on a simple tabletop base. In the same year, the artist obtained a stipend from the city of Hamburg.

1987

Balkenhol was invited to participate in "Skulptur Projekte in Münster," an exhibition of public art displayed throughout the city. The artist installed a concrete relief sculpture, *Man with Green Shirt and White Pants*, 1987, on a second-story masonry wall above a tobacco shop. In the same year, Balkenhol embarked on a three-week tour through Egypt.

1988

The artist taught at the Hochschule für Bildende Künste in Hamburg, from fall 1988 until summer 1989. The Kunsthalle Basel organized his first traveling show, "Stephan Balkenhol," also seen in Frankfurt and Nuremberg. Among other works, it featured Balkenhol's *Twelve Friends*, 1988, a series of twelve relief panels mounted in a grid on the wall.

1989

Balkenhol received a prize from the state of Baden-Württemberg (Förderpreis Zum Internationalen Preis des Landes Baden-Württemberg) and an award from the city of Bremen (Bremer Kunstpreis). He moved to a house located on the outskirts of Edelbach, a village southeast of Frankfurt near Aschaffenburg.

1990

In the spring, Balkenhol accepted a one-year teaching position at Hochschule für Bildende Künste in Frankfurt. He also set up a studio in Hamburg-St. Pauli. He mounted an exhibition of drawings and sketches, "Stephan Balkenhol: Zeichnungen und Entwürfe für Skulpturen," at the Deweer Art Gallery in Otegem, Belgium.

1991

In the fall, Balkenhol accepted a one-year teaching post at the Akademie für Bildende Künste in Karlsruhe, where he continues to teach. In the garden behind Städtische Galerie, Frankfurt, Balkenhol presented his first multiple-figure outdoor installation. This project included two small stone houses (one round, the other square), each enclosing a wood sculpture, *Man with White Shirt and Black Pants* and *Woman with Green Dress* respectively. A third figure, *Man with Red Shirt and Gray Pants,* was sited in a niche on the museum's rear façade, and a fourth was subsequently added to a niche on the lateral façade. Balkenhol also completed *57 Penguins,* 1991 (cat. no. 12), exhibited at the Galerie Johnen & Schöttle, Cologne, and acquired in May of the following year by the Museum für Moderne Kunst, Frankfurt. Balkenhol's son, Konstantin, was born to Alenka Klenenčič.

1992

The Hayward Gallery's exhibition "Doubletake: Collective Memory and Current Art" in London featured *Standing Figure on Buoy,* 1992, a work sited in the Thames River, and *Head of a Man,* 1992, mounted on a pedestal and installed atop a large piling adjoining Blackfriars Bridge. In the spring, Balkenhol closed his studio in Hamburg-St. Pauli, and in June he also gave up his studio in Hamburg-Volksdorf. The artist was promoted to professor by the Akademie für Bildende Künste in Karlsruhe in the fall. On December 12 the exhibition "Stephan Balkenhol: Über Menschen und Skulpturen/About Men and Sculpture" opened at the Witte de With Center for Contemporary Art, Rotterdam. Balkehol purchased property in Meisenthal, France, and subsequently (1993) built a studio there.

1993

Balkenhol received numerous outdoor commissions. Two circular wood reliefs of a male and a female head, *Tondi (Head of a Woman/ Head of a Man),* 1993 (cat. no. 21), were sited on the gables of the Deichtorhallen in Hamburg for the exhibition "Post Human." The Union Bank of Switzerland commissioned *Acrobats,* for installation in front of its corporate headquarters in Rapperswil, Switzerland. In the summer, Balkenhol installed *Three Heads on Moorings* for the exhibition "Kalkhaven NL Dordrecht: 51° 48'–04° 40'" in Dordrecht's harbor. He also mounted two relief figures, *Man with Red Shirt and Green Pants,* 1993, and *Woman with Green Dress,* 1993, on a wall in Amiens, and installed *Man on Buoy,* 1993. Later that summer, he positioned *Four Men on Buoys* at four different sites around Hamburg in the Alster Lake and on the Elbe River. The project, organized by the city of Hamburg, is on view annually from April through October. Balkenhol also carved two figures, *Adam and Eve,* 1993, exhibited in the Lamberti Kirche, Münster, as part of the group show "Gegenbilder." Balkenhol's first solo show in the United States was hosted at Regen Projects, Los Angeles. By the end of the year, Balkenhol closed his studio in Edelbach.

1994

Balkenhol made Meisenthal his permanent residence. He mounted a male head on a stone column in the Lisbon harbor as part of the event "The Day after Tomorrow: Lisbon, Cultural Capital of Europe '94." The Neue Nationalgalerie in Berlin hosted the exhibition "Stephan Balkenhol: Skulpturen," featuring the new works *Angel,* 1994, and *Devil,* 1994. Also among the works exhibited were several small sculptures pairing animals and humans, as well as the series *Sixteen Blackboard Drawings,* 1994 (cat. no. 28), depicting related subjects.

1995

Balkenhol had his first New York solo show, at the Barbara Gladstone Gallery. In the same year, he was selected to represent Germany in "Africus," the first Johannesburg Biennale. For this exhibition he completed *Global Couple,* 1995, standing black male and white female figures, which were mounted atop the façade of the pavilion entrance. An exhibition of sculptures and drawings, Balkenhol's first solo show in a North American museum, was held at the Hirshhorn Museum and Sculpture Garden, Smithsonian Institution, Washington, D.C., and scheduled to travel in 1996 to the Montreal Museum of Fine Arts.

Exhibition History

Within each year, entries are arranged in chronological order. An asterisk indicates a citation in the Bibliography.

SOLO EXHIBITIONS

1984
Mönchengladbach, West Germany. Galerie Löhrl. "Stephan Balkenhol: Neue Arbeiten" (September 16–October 10).

1985
Hamburg, West Germany. A. O. Kunstraum. "Stephan Balkenhol Skulpturen" (February 7–March 1).

Bochum, West Germany. Kunstverein Bochum. "Skulpturen Stephan Balkenhol" (September 28–November 10).

1987
*Braunschweig, West Germany. Kunstverein Braunschweig. "Stephan Balkenhol: Skulpturen und Zeichnungen" (February 6–March 15).

Otegem, Belgium. Deweer Art Gallery. "Stephan Balkenhol" (September 5–October 4).

1988
*Mönchengladbach, West Germany. Galerie Löhrl. "Stephan Balkenhol: Neue Skulpturen" (March 27–May 4).

*Basel, Switzerland. Kunsthalle Basel. "Stephan Balkenhol" (August 21–October 23). Traveled to Portikus, Frankfurt, West Germany (December 15, 1988–January 15, 1989), and Kunsthalle Nürnberg, Nuremberg, West Germany (April 14–June 4, 1989).

Cologne, West Germany. Galerie Johnen & Schöttle. "Stephan Balkenhol" (November 11–January 14, 1989).

1989
Munich, West Germany. Galerie Rüdiger Schöttle. "Stephan Balkenhol: Skulpturen" (May 20–June 30).

Lucerne, Switzerland. Mai 36 Galerie. "Stephan Balkenhol" (September 4–October 7).

*Baden-Baden, Germany. Staatliche Kunsthalle Baden-Baden. "Stephan Balkenhol" (October 28–December 3).

1990
*Otegem, Belgium. Deweer Art Gallery. "Stephan Balkenhol: Zeichnungen 1990 und Entwürfe für Skulpturen" (March 10–April 8).

Hamburg, Germany. Westwerk. "Skulpturen und Zeichnungen" (November 22–December 2).

1991
Paris, France. Galerie Rüdiger Schöttle. "Six Ours pour Paris" (February 9–March 16).

*Frankfurt, Germany. Städtische Galerie im Städel. "Stephan Balkenhol: Skulpturen im Städelgarten" (May 1991–1994).

*Cologne, Germany. Galerie Johnen & Schöttle. "Stephan Balkenhol" (July 5–August 10). Traveled to Kunstverein Ulm, Germany (August 25–September 29).

*Mönchengladbach, Germany. Galerie Löhrl. "Stephan Balkenhol: Köpfe" (October–December). Traveled to Lucerne, Switzerland, Mai 36 Galerie (December 7–January 11, 1992); Hamburg, Germany, Hamburger Kunsthalle (March 8–May 31, 1992); and Mannheim, Germany, Mannheimer Kunstverein (August 16–September 13, 1992).

*Dublin, Ireland. Irish Museum of Modern Art. "Stephan Balkenhol" (November 30, 1991–February 29, 1992).

1992
Paris, France. Galerie Roger Pailhas. "Stephan Balkenhol" (September 12–October 17).

Marseilles, France. Galerie Roger Pailhas. "Stephan Balkenhol" (October 15–December 31).

*Rotterdam, The Netherlands. Witte de With Center for Contemporary Art. "Stephan Balkenhol: Über Menschen und Skulpturen/About Men and Sculpture" (December 12, 1992–January 17, 1993).

1993
*Hamburg, Germany. Kulturbehörde Hamburg, Kunst im öffentlichen Raum. "Stephan Balkenhol: Vier Männer auf Bojen" (on view annually from April through October). Locations: Elbe, near Museumshafen Övelgönne, Hamburg-Altona; Süderelbe, Hamburg-Harburg; Serrahn, Hamburg-Bergedorf; Aussenalster, near Gurlittinsel, Hamburg-Mitte.

Bremerhaven, Germany. Kabinett für aktuelle Kunst. "Stephan Balkenhol: See Stücke" (May 14–June 13).

*Otegem, Belgium. Deweer Art Gallery. "Stephan Balkenhol: Skulpturen 1993" (June 5–July 4).

Amiens, France. Outdoor installation (summer).

Cologne, Germany. Galerie Johnen & Schöttle. "Stephan Balkenhol" (October 8–November 6).

Los Angeles, California. Regen Projects. "Stephan Balkenhol" (December 11, 1993–January 29, 1994).

1994
*Mönchengladbach, Germany. Galerie Löhrl. "Stephan Balkenhol: Skulpturen und Zeichnungen" (March 13–April 21). Traveled to Wolfsburg, Germany, Kunstverein Wolfsburg (April 24–June 19).

Hannover, Germany. Kunstraum Neue Kunst. "Stephan Balkenhol: Skulpturen" (April 4–May 20).

Amsterdam, The Netherlands. Galerie Akinci. "Stephan Balkenhol" (June 4–July 16).

*Rochechouart, France. Musée Départemental d'Art Contemporain de Rochechouart. "Stephan Balkenhol" (July 8–September 18). Traveled to Dôle, France, Musée des Beaux-Arts (October 1–December 4); Haute-Normandie, France, Musée des Beaux-Arts (December 10, 1994–February 28, 1995).

*Berlin, Germany. Neue Nationalgalerie. "Stephan Balkenhol: Skulpturen" (August 31–October 30).

Hamburg, Germany. Galerie Dörrie & Priess. "Stephan Balkenhol: Neue Arbeiten" (September 9–October 15).

Zürich, Switzerland. Mai 36 Galerie. "Stephan Balkenhol: Skulpturen und Zeichnungen" (October 7–November 12).

1995
New York, New York. Barbara Gladstone Gallery. "Stephan Balkenhol" (May 16–June 30).

*Garmisch-Partenkirchen, Germany. Bayerische Zugspitzbahn AG in cooperation with Kunstalle Nürnberg. "Kunst auf der Zugspitze" (July 1–October 22).

GROUP EXHIBITIONS

1983
*Mönchengladbach, West Germany. Galerie Löhrl. "Impulse 1" (May 15–June 22).

1984
*Berlin, West Germany. Brücke-Museum. "Die Stipendiaten der Karl-Schmidt-Rottluff Förderungsstiftung" (April 7–May 13).

Bonn, West Germany. Landesvertretung der Freien und Hansestadt Hamburg. "Skulptur in Hamburg" (June 13–July 27).

Düsseldorf, West Germany. Kunstverein Düsseldorf. "Es ist wie es ist: 15 junge Künstler in Deutschland" (September 29–November 25).

1985
*Darmstadt, West Germany. Ausstellungshallen Mathildenhöhe. "Die Karl-Schmidt-Rottluff Stipendiaten" (March 21–April 21).

1986
*Hamburg, West Germany. Kulturbehörde Hamburg, Jenisch Park. "Jenisch-Park Skulptur" (June 1–November 30).

Braunschweig, West Germany. Kunstverein Braunschweig. "Momente – zum Thema Urbanität" (August 3–September 7).

Kassel, West Germany. Kasseler Kunstverein. "S. Balkenhol, L. Gerdes, E. Karnauke" (October 16–November 9).

*Otegem, Belgium. Deweer Art Gallery and Internationaal Cultureel Centrum, Antwerpen. "Neue Deutsche Skulptur" (November 22–December 21).

1987
*Hamburg, West Germany. Kampnagelfabrik. "Neue Kunst in Hamburg" (February 6–March 8).

*Münster, West Germany. Westfälisches Landesmuseum für Kunst und Kulturgeschichte. "Skulptur Projekte in Münster" (June 14–October 4).

*Amsterdam, The Netherlands. Kunstrai 1987. "Een keuze: Hedendaagse kunst uit Europa/A Choice: Comtemporary Art from Europe" (June).

Nancy, France. Park de la Pepiniere. "Été de la Sculpture" (summer).

Stuttgart, West Germany. Württembergischer Kunstverein. "Exotische Welten-Europäische Phantasien" (September 1–November 29).

Cologne, West Germany. Galerie Johnen & Schöttle. "Stephan Balkenhol, Werner Kütz, Jan Vercruysse" (September 11–October 10).

Munich, West Germany. Künstlerwerkstatt Lothringerstrasse. "Theatergarten-Bestiarium" (October 22–November 22).

1988
*Bonn, West Germany. Städtisches Kunstmuseum Bonn. "Dorothea von Stetten-Kunstpreis 1988" (May 4–June 5).

*Düsseldorf, West Germany. Städtische Kunsthalle Düsseldorf, Kunstsammlung Nordrhein-Westfalen, and Kunstverein für die Rheinlande und Westfalen. "Binationale: German Art of the Late 80's/American Art of the Late 80's" (September 24–November 27). Traveled to Boston, Massachusetts, The Institute of Contemporary Art and the Museum of Fine Arts (December 16, 1988–January 29, 1989).

1989
Frankfurt, Germany. Frankfurter Kunstverein und Schirn Kunsthalle. "Prospekt 89: Eine internationale Ausstellung aktueller Kunst" (March 21–May 21).

Fellbach, Germany. "4. Triennale der Kleinplastik" (summer).

*Turin, Italy. Castello di Rivara. "Sei Artisti Tedeschi" (September 22–November 5).

*Munich, Germany. Nymphenburger Schlosspark, organized by Kunstverein München in cooperation with Bayerische Verwaltung der Staatlichen Schlösser, Gärten und Seen. "Das goldene Zimmer" (October 10–November 12).

*Bremen, Germany. Kunsthalle Bremen in cooperation with Stifterkreis Bremer Kunstpreis. "Bremer Kunstpreis 1989" (October 29–November 26).

1990
Newcastle, England. First Tyne International. "A New Necessity"(May 18–October 21).

*London, England. Institute of Contemporary Arts and Serpentine Gallery. "Possible Worlds: Sculpture from Europe" (November 9, 1990–January 6, 1991).

1991
*Malmö, Sweden. Konstmuseet Malmö. "Tio års ung konst i Hamburg 80/90" (January 27–February 24).

*Heilbronn, Germany. Deutschhof, Städtische Museen Heilbronn. "Ansichten von Figur in der Moderne" (February 1–April 21).

New York, New York. Andrea Rosen Gallery. "Seven Women" (February 22–March 23).

*Basel, Switzerland. Kunstmuseum Basel. "Karl August Burckhardt-Koechlin-Fonds: Zeichnungen des 20. Jahrhunderts" (September 1–December 8).

*Leverkusen, Germany. Erholungshaus der Bayer AG. "Zeitgenössische Kunst aus der Deutschen Bank: Skulptur, Zeichnung, Photographie" (February 17–March 24). Traveled to Bozen, Museum für Moderne Kunst (August 8–October 5); Hoecht, Galerie Jahrhunderthalle (October 13–November 8).

Ipswich, England. European Visual Arts Centre. "Hamburg Abroad" (November 30–January 26, 1992).

1992
*London, England. Hayward Gallery. "Doubletake: Collective Memory and Current Art" (February 20–April 20). Traveled to Vienna, Kunsthalle Wien (January 8–February 28, 1993).

Zurich, Switzerland. Mai 36 Galerie. "Die 29. Austellung" (February 25–March 14).

Seville, Spain. EXPO '92. "Current Art in Public Spaces" (summer).

Hamburg, Germany. Galerie Dörrie & Priess. "Tiere" (May 21–July 11). Traveled to Frankfurt, Galerie Tröster & Schlüter (September 11–October 17).

Cologne, Germany. Galerie Johnen & Schöttle. "Double Identity" (June 5–August 29).

Lausanne, Switzerland. FAE Musée d'Art Contemporain. "Post Human" (June 14–September 13). Traveled to Turin, Castello di Rivoli, Museo d'Arte Contemporanea (September 24–November 22, 1992); Athens, Deste Foundation for Contemporary Art (December 3, 1992–February 14, 1993); Hamburg, Deichtorhallen (March 12–May 9, 1993).

Munich, Germany. Galerie Bernd Klüser. "Der gefrorene Leopard" (October 6–November 24).

Paris, France. Musée d'Art Moderne de la Ville de Paris.'Qui, Quoi, Où?: Un regard sur l'art en Allemagne en 1992" (October 22, 1992–January 17, 1993).

1993
*Nuremberg, Germany. Germanisches Nationalmuseum. "Ludwig's Lust: Die Sammlung Irene und Peter Ludwig" (June 19–October 10).

Münster, Germany. Installation at Lamberti Kirche. "Gegenbilder" (August 6–November 15).

*Dordrecht, The Netherlands. Kalkhaven, Centrum Beeldende Kunst Dordrecht. "Kalkhaven NL Dordrecht: 51° 48'–04° 40'" (summer).

*Düsseldorf, Germany. Städtische Kunsthalle Düsseldorf. "Karl-Schmidt-Rottluff Stipendium" (December 1993–January 1994).

1994
Washington, D.C. Baumgartner Galleries. "Summer Group Show" (July 9–August 20).

Hamburg, Germany. Deichtorhallen. "Das Jahrhundert der Multiple" (September 2–October 30).

Lisbon, Portugal. Centro Cultural de Belém. "The Day after Tomorrow: Lisbon, Cultural Capital of Europe '94" (September 20–December 18).

New York, New York. Barbara Gladstone Gallery. "Still Life" (December 15, 1994–January 28, 1995).

1995
Cologne, Germany. Galerie Johnen & Schöttle. "Philip Akkerman/Stephan Balkenhol" (March 24–April 29).

*Johannesburg, South Africa. "Africus: Johannesburg Biennale '95." (spring).

Zurich, Switzerland. Kunsthaus Zürich. "Zeichen & Wunder" (March 31–June 18). Traveled to Santiago de Compostela, Spain, Centro Galego de Arte Contemporánea (July 20–October 20).

Milan, Italy. Galerie Monica de Cardenas. "People" (June–July).

Pittsburgh, Pennsylvania. "1995 Carnegie International" (November 4, 1995–February 18, 1996).

78 Bibliography

Within each year, entries are arranged alphabetically by city. The city and name of the publisher follow the publication title if the publisher is different from the organizing institution.

EXHIBITION CATALOGS AND BROCHURES

1983
Mönchengladbach, West Germany. Galerie Löhrl. *Impulse 1.* Essay by Dietrich Helms.

1984
Berlin, West Germany. Brücke-Museum. *Die Stipendiaten der Karl-Schmidt-Rottluff Förderungsstiftung.*

1985
Darmstadt, West Germany. Ausstellungshallen Mathildenhöhe. *Stephan Balkenhol: Skulpturen.* Introduction by Ulrich Rückriem. Berlin: Karl Schmidt-Rottluff Förderungsstiftung, 1985.

1986
Hamburg, West Germany. Kulturbehörde Hamburg-Kunst im öffentlichen Raum. *Jenisch-Park Skulptur.* Essay by Bernd Ernsting.

Otegem, Belgium. Deweer Art Gallery and Internationaal Cultureel Centrum, Antwerpen. *Neue Deutsche Skulptur.*

1987
Braunschweig, West Germany. Kunstverein Braunschweig. *Stephan Balkenhol: Skulpturen und Zeichnungen.* Introduction by Wilhelm Bojescul; essay by Ludger Gerdes.

Hamburg, West Germany. Kampnagelfabrik. *Neue Kunst in Hamburg.* Essay by Günther Gercken.

Münster, West Germany. Westfälisches Landesmuseum für Kunst und Kulturgeschichte. *Skulptur Projekte in Münster.* Text by Klaus Bussmann and Kasper König. Cologne: DuMont, 1987.

Amsterdam, The Netherlands. Kunstrai 1987. *Een keuze: Hedendaagse kunst uit Europa/A Choice: Contemporary Art from Europe.*

1988
Basel, Switzerland. Kunsthalle Basel. *Stephan Balkenhol.* Essays by Jean-Christophe Ammann and Jeff Wall.

Bonn, West Germany. Städtisches Kunstmuseum Bonn. *Dorothea von Stetten-Kunstpreis 1988.* Essay by Dieter Koepplin.

Düsseldorf, West Germany. Städtische Kunsthalle Düsseldorf. *Binationale: German Art of the Late 80's/American Art of the Late 80's.* Interview by Marie Luise Syring and Christiane Vielhaber. Cologne: DuMont, 1988.

Mönchengladbach, West Germany. Galerie Löhrl. *Stephan Balkenhol: Neue Skulpturen.*

1989
Baden-Baden, Germany. Staatliche Kunsthalle Baden-Baden. *Stephan Balkenhol.* Introduction by Dirk Teuber.

Bremen, Germany. Kunsthalle Bremen. *Bremer Kunstpreis 1989.* Essay by Günther Gercken. Bremen: Stifterkreis Bremer Kunstpreis, 1989.

Munich, Germany. Nymphenburger Schlosspark, organized by Kunstverein München in cooperation with Bayerische Verwaltung der Staatlichen Schlösser, Gärten und Seen. *Das Goldene Zimmer.* Text by Rüdiger Schöttle.

Turin, Italy. Castello di Rivara. *Sei Artisti Tedeschi.* Brochure.

1990
London, England. Institute of Contemporary Arts and Serpentine Gallery. *Possible Worlds: Sculpture from Europe.* Interview by Iwona Blazwick, James Lingwood, and Andrea Schlieker.

Otegem, Belgium. Deweer Art Gallery. *Stephan Balkenhol: Zeichnungen 1990 und Entwürfe für Skulpturen.*

1991
Basel, Switzerland. Kunstmuseum Basel. *Karl August Burckhardt-Koechlin-Fonds: Zeichnungen des 20. Jahrhundert.* Biography by Patricia Nussbaum.

Cologne, Germany. Galerie Johnen & Schöttle. *Stephan Balkenhol.* Brochure.

Dublin, Ireland. Irish Museum of Modern Art. *Stephan Balkenhol.* Text by Jörg Johnen.

Frankfurt, Germany. Städtische Galerie im Städel. *Stephan Balkenhol: Skulpturen im Städelgarten.* Introduction by Klaus Gallwitz; essay by Ursula Grzechca-Mohr.

Heilbronn, Germany. Deutschhof, Städtische Museen Heilbronn. *Ansichten von Figur in der Moderne.* Text by Karlheinz Nowald. Heilbronn: Städtische Galerie, 1991.

Ipswich, England. European Visual Arts Centre at Ipswich. *Hamburg Abroad.* Text by Janis Mink.

Leverkusen, Germany. Erholungshaus der Bayer AG. *Zeitgenössische Kunst aus der Deutschen Bank: Skulptur, Zeichnung, Photographie.*

Malmö, Sweden. Konstmuseet Malmö. *Tio års ung konst i Hamburg 80/90.*

Mönchengladbach, Germany. Galerie Löhrl. *Stephan Balkenhol: Köpfe.* Introduction by Martin Stather.

1992
London, England. Hayward Gallery. *Doubletake: Collective Memory and Current Art.* Essays by Lynne Cooke, Bice Curiger, and Greg Hilty. London: South Bank Centre/Parkett, 1992.

Rotterdam, The Netherlands, Witte de With Center for Contemporary Art. *Stephan Balkenhol: Über Menschen und Skulpturen/About Men and Sculpture.* Texts by Stephan Balkenhol, James Lingwood, and Jeff Wall; interviews by Ulrich Rückriem and Thomas Schütte. Stuttgart: Edition Cantz, 1992.

1993
Dordrecht, The Netherlands. Kalkhaven, Centrum Beeldende Kunst Dordrecht. *Kalkhaven NL Dordrecht: 51° 48'–0° 40.'* Statement in English and Dutch by Stephan Balkenhol, reprinted from Volker Plagemann, ed. *Kunst im öffentlichen Raum: Anstösse der 80er Jahre.* Cologne: DuMont, 1989, 260.

Düsseldorf, Germany. Städtische Kunsthalle Düsseldorf. *Karl Schmidt-Rottluff Stipendium.* Introductions by Jürgen Harten and Klaus Heinrich Kohrs. Berlin: Karl Schmidt-Rottluff Förderungsstiftung, 1993.

Hamburg, Germany. Kulturbehörde Hamburg, Kunst im öffentlichen Raum. *Stephan Balkenhol: Vier Männer auf Bojen.* Brochure. Text by Achim Könneke.

Nuremberg, Germany. Germanisches Nationalmuseum. *Ludwig's Lust: Die Sammlung Irene und Peter Ludwig.* Biography by Margret Ribbert.

Otegem, Belgium. Deweer Art Gallery. *Stephan Balkenhol: Skulpturen 1993.*

1994
Berlin, Germany. Neue Nationalgalerie. *Stephan Balkenhol: Skulpturen.* Introduction by Britta Schmitz. Berlin: Staatliche Museen zu Berlin, Nationalgalerie, 1994.

Lisbon, Portugal. Centro Cultural de Belém. *The Day after Tomorrow: Lisbon, Cultural Capital of Europe '94.* Text by Helmut Friedel.

Mönchengladbach, Germany. Galerie Löhrl and Kunstverein Wolfsburg. *Stephan Balkenhol: Skulpturen und Zeichnungen.* Text by Susanne Pfleger and Klaus Hoffmann. Mannheim: Vits & Kehrer, 1994.

Rochechouart, France. Musée Départemental d'Art Contemporain de Rochechouart. *Stephan Balkenhol.* Interview by Alexandra Midal; essay by Frédéric Migayrou.

1995
Garmisch-Partenkirchen, Germany. *Kunst auf der Zugspitze.* Brochure. Text by Lucius Grisebach.

Johannesburg, South Africa. "Africus: Johannesburg Biennale '95." Text by Klaus Gallwitz.

NEWSPAPER AND JOURNAL ARTICLES

Ammann, Jean-Christophe. "Stephan Balkenhol: 57 Penguins/57 Pinguine." *Parkett* 36 (1993): 66–69.

Ammann, Jean-Christophe, and Horst Schmitter. "57 Pinguine suchen 57 Freunde," advertisement. *Frankfurter Allgemeine Zeitung,* 30 April 1992, no. 101, 11.

Ardenne, Paul. "Stephan Balkenhol." Exhibition review, Galerie Roger Pailhas, Paris. *Art Press* 175 (December 1992): 76.

"Balkenhol, l'homme du bois." Exhibition review, Musée des Beaux-Arts, Dôle, France. *Le Progrès/Dépêches,* 3 October 1994.

Benezra, Neal. "Stephan Balkenhol: The Figure as Witness/Die Figur als stummer Zeuge." *Parkett* 36 (1993): 37–41.

Beyer, Lucie. "Stephan Balkenhol, Werner Kutz, Jan Vercruysse." Exhibition review, Galerie Johnen & Schöttle, Cologne, West Germany. *Flash Art,* no. 137 (November-December 1987): 111–12.

Bourriaud, Nicholas. "Figuration in an Age of Violence." *Flash Art* 25, no. 162 (January–February 1992): 87–91.

Brenken, Anna. "Stephan Balkenhol, Bildhauer." *Art: Das Kunstmagazin* 1 (January 1989): 42–50.

Cork, Richard. "Do You See What I See?" Exhibition review, Hayward Gallery, London, England. *Times* (London), 28 February 1992, Life and Times section.

Crüwell-Doertenbach, Konstanze. "Stephan Balkenhol." *Nike* 27 (April 1989): 24–25.

Czöppan, Gabi. "Menschen wie Du und Ich." *Pan* (March 1992): 64–69.

Decter, Joshua. "Seven Women." Exhibition review, Andrea Rosen Gallery, New York, New York. *Arts Magazine* 65, no. 9 (May 1991): 103.

Fell, Judith. "Skulptur als Abenteuer." *Hamburger Morgenpost,* 25 June 1992, 37.

Fleissig, Peter. "Stephan Balkenhol, Juan Muñoz at the Hayward Doubletake and the New Tate Re-Hang." Exhibition review, Hayward Gallery, London, England. *City Limits* 5, no. 12 (February–March 1992): 18.

Flemming, H. Th. "Gesichter aus Buche und Pappel geschnitzt." Exhibition review, Hamburger Kunsthalle, Hamburg. *Die Welt* (Hamburg), 12 March 1992.

Fleming, Lee. "Worthy of Their Big Names." Exhibition review, Baumgartner Galleries, Washington, D.C. *Washington Post,* 13 August 1994, C2.

Frick, Thomas. "Stephan Balkenhol at Regen Projects." Exhibition review, Regen Projects, Los Angeles. *Art in America* 82, no. 6 (June 1994): 108.

Glueck, Grace. "Mutant Materials (but No Rogue Genes); Notes, Letters and Typographic Wackiness." Exhibition review, Barbara Gladstone Gallery, New York. *New York Observer,* 19 June 1995, 21.

Gourmelon, Mo. "Stephan Balkenhol." Exhibition review, Musée Départemental d'Art Contemporain de Rochechouart, France. *Beaux Arts Magazine* (Paris) 125 (July–August 1994): 96–97.

Hegewisch, Katharina. "Stephan Balkenhol: Vom Ewigen im Zeitgemässen." *Kunstbulletin* 9 (September 1991): 12–16.

Hierholzer, Michael. "Bildkritik mit malerischen Mitteln und die Befreiung des Lichts: Der sechste Szenenwechsel im Museum für Moderne Kunst." *Frankfurter Allgemeine Sonntagszeitung,* 12 June 1994, no. 23, 26.

80 Hohmeyer, Jürgen. "Götzen wie Du und Ich." *Der Spiegel* 47 (1991): 314–16.

————. "Szenenwechsel." *Kunstforum International* 120 (November–December 1992): 345–46.

Huther, Christian. "Stephan Balkenhol." Exhibition review, Kunsthalle Basel, Switzerland. *Das Kunstwerk* 41 (1988): 89–90.

Karmel, Pepe. "Stephan Balkendhol." Exhibition review, Barbara Gladstone Gallery, New York. *New York Times* 23 June 1995, Weekend section, C23.

————. "Still Life." Exhibition review, Barbara Gladstone Gallery, New York. *New York Times* 30 December 1994.

Katz, Max. "Autonomous People/Autonome Menschen." *Parkett* 36 (1993): 58–59.

Koepplin, Dieter. "Stephan Balkenhol." *Parkett* 22 (1989): 6–10.

Magnani, Gregorio. "This Is Not Conceptual." *Flash Art*, no. 145 (March–April 1989): 84–87.

Messler, Norbert. "Stephan Balkenhol." Exhibition review, Galerie Johnen & Schöttle, Cologne. *Artforum* 30 (November 1991): 150–51.

————. "Stephan Balkenhol." Exhibition review, Galerie Johnen & Schöttle, Cologne. *Artforum* 32 (December 1993): 91–92.

Muniz, Vik. "As Time Goes By/Im Lauf der Zeit." *Parkett* 36 (1993): 48–50.

Richie, Matthew. "Still Life." Exhibition review, Barbara Gladstone Gallery, New York. *Flash Art* 28, no. 181 (March–April 1995): 65.

Searle, Adrian. "Not Waving, Not Drowning." *Frieze* 4 (April–May 1992): 17–20.

————. "Cumulus Aus Europa." *Parkett* 38 (December 1993): 162–69.

Sello, Gottfried. "Holzköpfe." Exhibition review, Hamburger Kunsthalle, Hamburg. *Die Zeit* (Hamburg), 20 March 1992, 69.

"Stephan Balkenhol." Exhibition review, Musée des Beaux-Arts, Dôle, France. *Art & Aktoer*, no. 7 (October–December 1994).

"Stephan Balkenhol." Exhibition review, Musée des Beaux-Arts, Dôle, France. *L'Art Scène*, no. 3 (October 5–11, 1994).

"Stephan Balkenhol: La vie qui naît du bois." Exhibition review, Musée des Beaux-Arts, Dôle, France. *L'Est Républicain*, 26 November 1994.

Stringer, Robin. "Why Cant You Dummies Just Let Me Be Alone?" Exhibition review, Hayward Gallery, London, England. *Evening Standard* (London), 28 February 1992.

Teuber, Dirk. "Die Kraft der Einfachheit: Zum Werk Stephan Balkenhols." *Weltkunst* 21 (November 1993): 2954–56.

Vergne, Philippe. "Stephan Balkenhol: De l'autre côté du miroir." Interview. *Parachute* 72 (1993): 22–25.

Vogel, Sabine B. "Querblicke." Exhibition review, Kunsthalle Basel, Switzerland. *Wolkenkratzer Art Journal* 6 (November–December 1988): 80–82.

Walser, Alissa. "Jedes Gesicht eröffnet einen neuen Raum." *Art: Das Kunstmagazin* 2 (February 1994): 54–55.

Welzer, Harald. "Über Stephan Balkenhol." *Artist Kunstmagazin* 21 (March 1994): 48–51.

Winter, Peter. "Baum-Menschen." Exhibition review, Kunstverein Braunschweig, West Germany. *Frankfurter Allgemeine*, 10 March 1987, no. 58, 27.

OTHER

Costa, Oswaldo, Barbera van Kooij, and Robin Resch, eds. "The Body Is Present: Stephan Balkenhol, Jean-François Chevrier, Chris Dercon, Craigie Horsfield, Ludger Gerdes, Martin Kreyssig, Jeff Wall." Symposium held December 13, 1992, and published as *The Lectures*. Rotterdam: Witte de With Center for Contemporary Art, 1993.

Plagemann, Volker, ed. *Kunst im öffentlichen Raum: Anstösse der 80er Jahre*. Cologne: DuMont, 1989.

Scheutle, Rudolf. "Stephan Balkenhol: Bilder vom Menschen." Master's thesis, Ludwig-Maximilians-Universität, Munich, April 1994.

List of Figure Illustrations

82

Fig. 24, p. 47
Untitled, 1995, pen and ink on paper, 5 3/4 x 8 3/16 (14.8 x 21 cm).
Galerie Löhrl, Mönchengladbach, Germany.

Fig. 25, p. 50
Man on Buoy, 1993, painted oak and steel. Installed as part of the
project "Four Men on Buoys" (1993–present) at Aussenalster, near
Gurlitt Island, Hamburg.

Fig. 26, p. 50
Installation of "Stephan Balkenhol: Skulpturen im Städelgarten,"
Städtische Galerie im Städel, Frankfurt, 1991.

Fig. 27, p. 51
Man with Red Shirt and Gray Pants, 1993, painted poplar, height
111 1/8 in. (285 cm). Installed in Amiens, June 1993.

Fig. 28, p. 52
Untitled, 1993, pen and ink on paper, 8 1/4 x 12 in. (21 x 30.5 cm).
Collection Ellen de Bruijne, Amsterdam.

Fig. 29, p. 52
Amiens Cathedral, West portal, left doorway, left jamb, 1225–35.

Fig. 30, p. 63
Pablo Picasso (Spanish, 1881–1973), *Man with a Sheep*, 1943–44,
bronze, height 79 1/2 in. (201.9 cm). Philadelphia Museum of Art,
Pennsylvania; Given by R. Sturgis and Marion B. F. Ingersoll.

Fig. 31, p. 64
Global Couple, 1995, painted oak, height 90 5/8 in. (230 cm). Installed
in "Africus: Johannesburg Biennale '95," South Africa, spring 1995.

Fig. 32, p. 65
Thomas Schütte (German, b. 1954), *The Strangers*, 1992, glazed
ceramic, approx. 60 in. (152.4 cm). Installed in "Documenta 9,"
Friedrichsplatz, Kassel, 1992.

Fig. 33, p. 66
Replica of the Statue of Liberty being paraded in Tianamen Square,
Beijing, China, May 30, 1989.

Fig. 34, p. 66
Removal of bronze Statue of Lenin, Bucharest, Romania, March
1990.

Fig. 35, p. 69
Untitled, 1982, pen and ink on paper. Collection of the artist.

Fig. 36, p. 70
Male and Female Heads, 1982, painted poplar, height 35 in. (90 cm).
Museum Ludwig, Cologne.

Fig. 37, p. 72
Stephan Balkenhol in his studio in Hamburg-St. Pauli, 1991.

Art Consulting Siebenhaar, Frankfurt
Barbara Gladstone Gallery, New York
L. Beunen-Akinci, Amsterdam
Dr. Dammann, Hamburg
Gabriele Fehm-Wolfsdorf and Lorenz H. Fehm, Lübeck, Germany
Galerie von Braunbehrens, Munich
Galerie Löhrl, Mönchengladbach, Germany
Christoph Graf Hardenberg, Hamburg
Hirshhorn Museum and Sculpture Garden, Smithsonian Institution, Washington, D.C.
Jedermann Collection, N.A.
Dr. Udo von Klot-Heydenfeldt, Kronberg, Germany
Kunstverein Bremerhaven v. 1886 e.V., Germany
Ludwig Forum für Internationale Kunst, Aachen, Germany
Mai 36 Galerie, Zurich
George P. Mills, New York
The Montreal Museum of Fine Arts
Musée Départemental d'Art Contemporain de Rochechouart, France
Museum für Moderne Kunst, Frankfurt
The Neuberger & Berman Collection, New York
Private collection, Berg, Germany; courtesy Galerie von Braunbehrens, Munich
Private collection, Munich
Private collection, Otegem, Belgium; courtesy Deweer Art Gallery, Otegem
Private collection, Switzerland
H. + H. Quadflieg, Düsseldorf
Mr. & Mrs. Harold E. Rayburn, Davenport, Iowa
Michael and Tini Rosenblat, Hamburg
Elisabeth Ruhland, Düsseldorf
Wilhelm Sandmann, Hannover
Horst + Vivien Schmitter, Hamburg
Reiner Stadler and Maja Stadler-Euler, Hamburg
Hans Jochen and Sabine Waitz, Hamburg

Photographic Credits

Photographs of all the works by Stephan Balkenhol were generously provided by the artist and are © Stephan Balkenhol. The author wishes to thank him as well as the museums, galleries, and private collectors who supplied photographs of works of art in their possession and/or granted permission for works in their collections to be reproduced as illustrations. Comparative photographic material other than that provided by Balkenhol was obtained directly from the collection cited in the List of Figure Illustrations (pp. 81–82); additional information is given below. The following photographs are reproduced with permission, as indicated:
Fig. 2. Courtesy Thomas Ammann Fine Art, Zurich. © Neil Jenney; Fig. 3. Courtesy Hallen für Neue Kunst, Schaffhausen, Germany. © Gerhard Richter. Photo by Robert Raussmüller; Figs. 9 and 10. Reproduced from *Stephan Balkenhol: Über Menschen und Skulpturen/About Men and Sculpture* (Stuttgart: Edition Cantz, 1992), pp. 26–27; Fig. 13. Courtesy Westfälisches Landesmuseum für Kunst und Kulturgeschichte, Münster/ARS, New York. © Richard Serra. Photo by Rudolf Wakonigg; Fig. 14. Courtesy Westfälisches Landesmuseum für Kunst und Kulturgeschichte, Münster. © Jeff Koons; Fig. 15. Courtesy Westfälisches Landesmuseum für Kunst und Kulturgeschichte, Münster. © Katharina Fritsch. Photo by Rudolf Wakonigg; Fig. 17. Courtesy Marian Goodman Gallery, New York. © Jeff Wall; Fig. 18. Courtesy 303 Gallery, New York. © Thomas Ruff; Fig. 19. © The Andy Warhol Foundation for the Visual Arts, New York/ARS, New York. Photo by Eric Pollitzer; Fig. 21. Courtesy Museum für Moderne Kunst, Frankfurt. © Roy Lichtenstein. Photo by Robert Häusser, Mannheim; Fig. 29. Reproduced from Willibald Sauerländer, *Gothic Sculpture in France 1140–1270* (London: Thames and Hudson, 1972), fig. 169; Fig. 30. © Philadelphia Museum of Art, Pennsylvania; Fig. 32. © Courtesy Marian Goodman Gallery, New York. © Thomas Schütte; Figs. 33 and 34. © AP/Wide World Photos.
Photographs provided by the Hirshhorn Museum and Sculpture Garden (p. 8, figs. 1, 9, 10, 20, and 28) were taken by Lee Stalsworth and Ricardo Blanc.

Designed by Gabriele Sabolewski
Typeset in Plantin by Weyhing GmbH, Stuttgart
Color separations by C + S Repro, Filderstadt
Printed on Samtoffset 170 g/sqm and Gardapat 150 g/sqm papers by
Dr. Cantz'sche Druckerei, Ostfildern
Bound by Bramscher Buchbinderbetriebe, Bramsche

Published by
Cantz Verlag
73760 Ostfildern, Germany, Senefelderstrasse 9
Tel. 07 11/4 49 93-0, Fax 4 41 45 79

US Distribution
D.A.P., Distributed Art Publishers
636 Broadway, 12th Floor, New York, N.Y. 10012
Tel. 212-473-5119, Fax 212-673-28 87

ISBN 3–89322–770–9

Printed in Germany

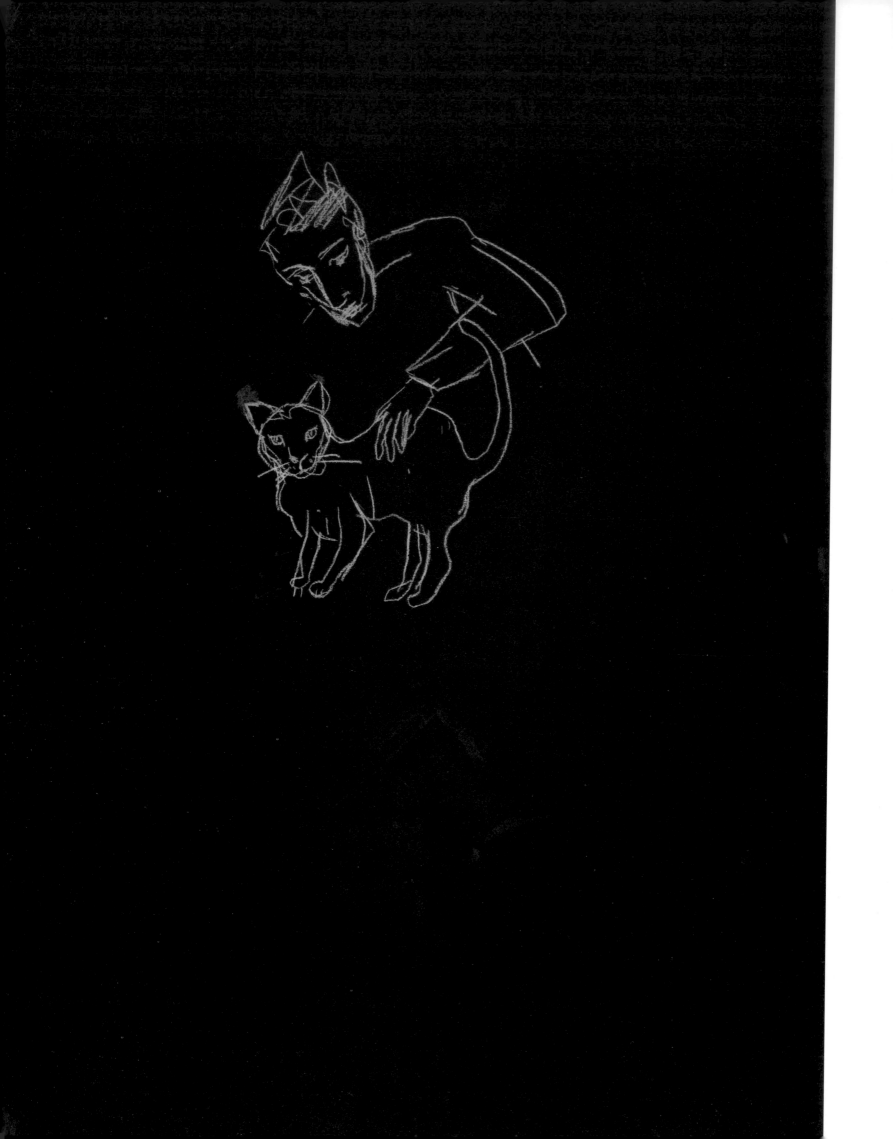

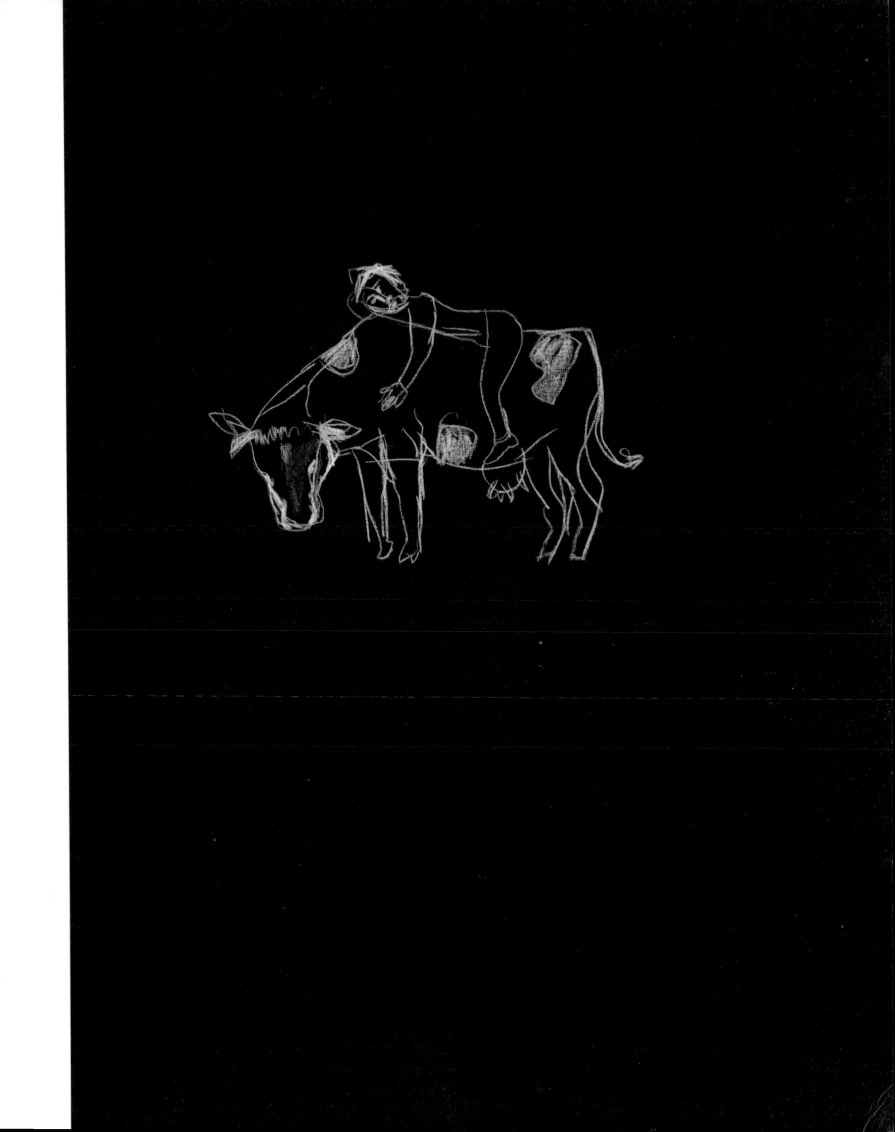

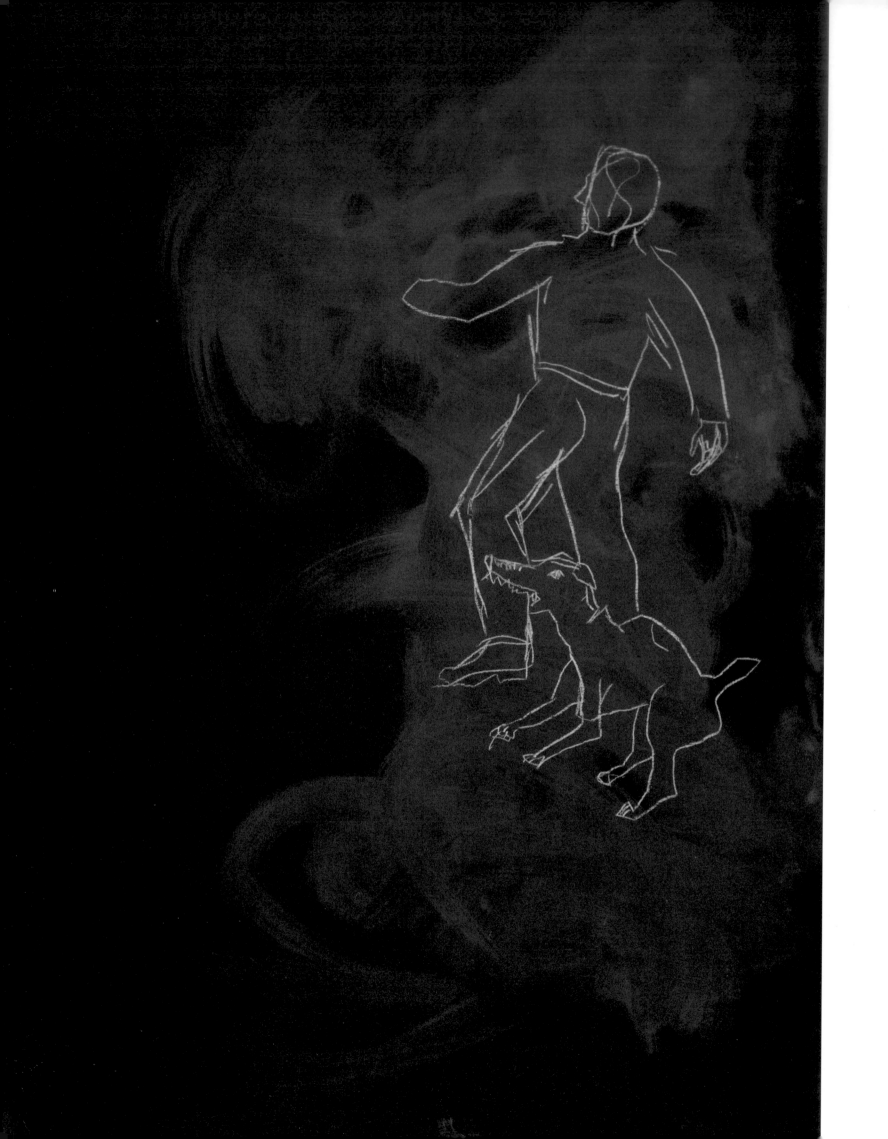

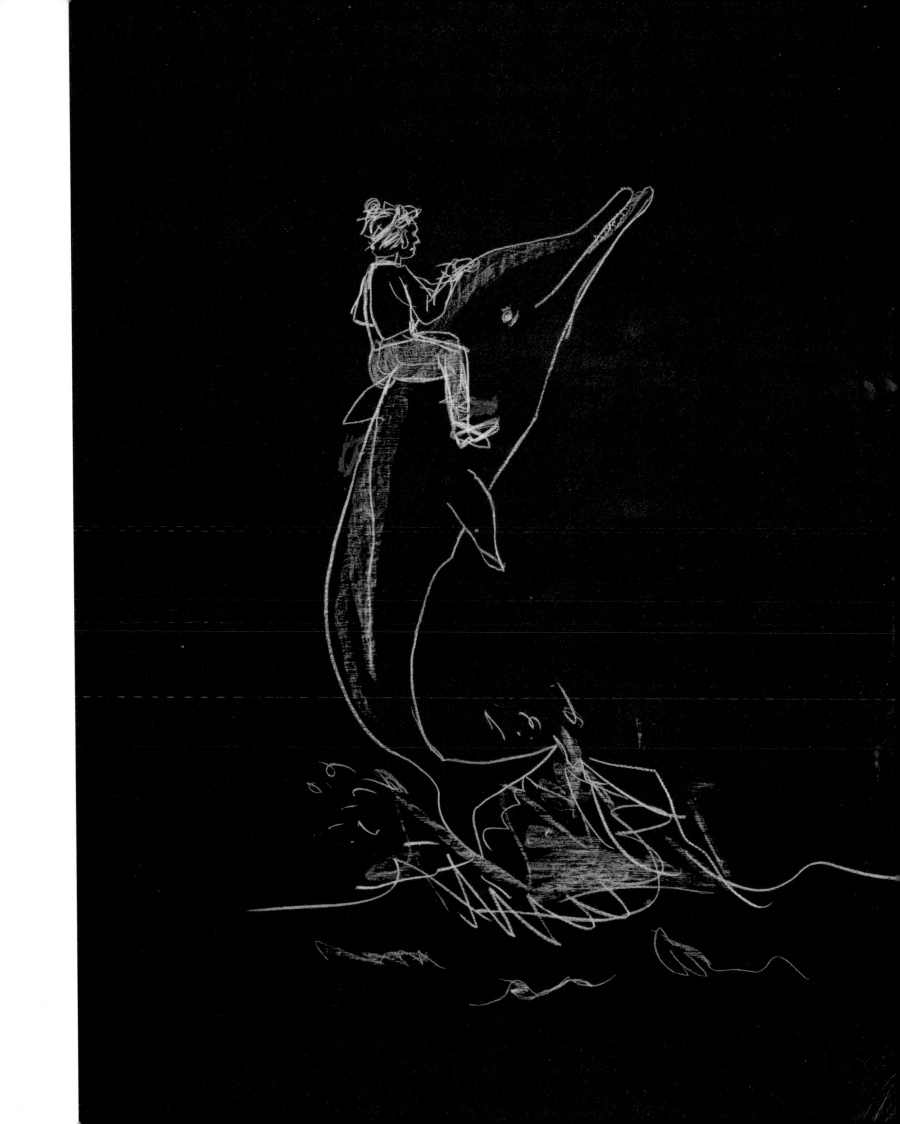

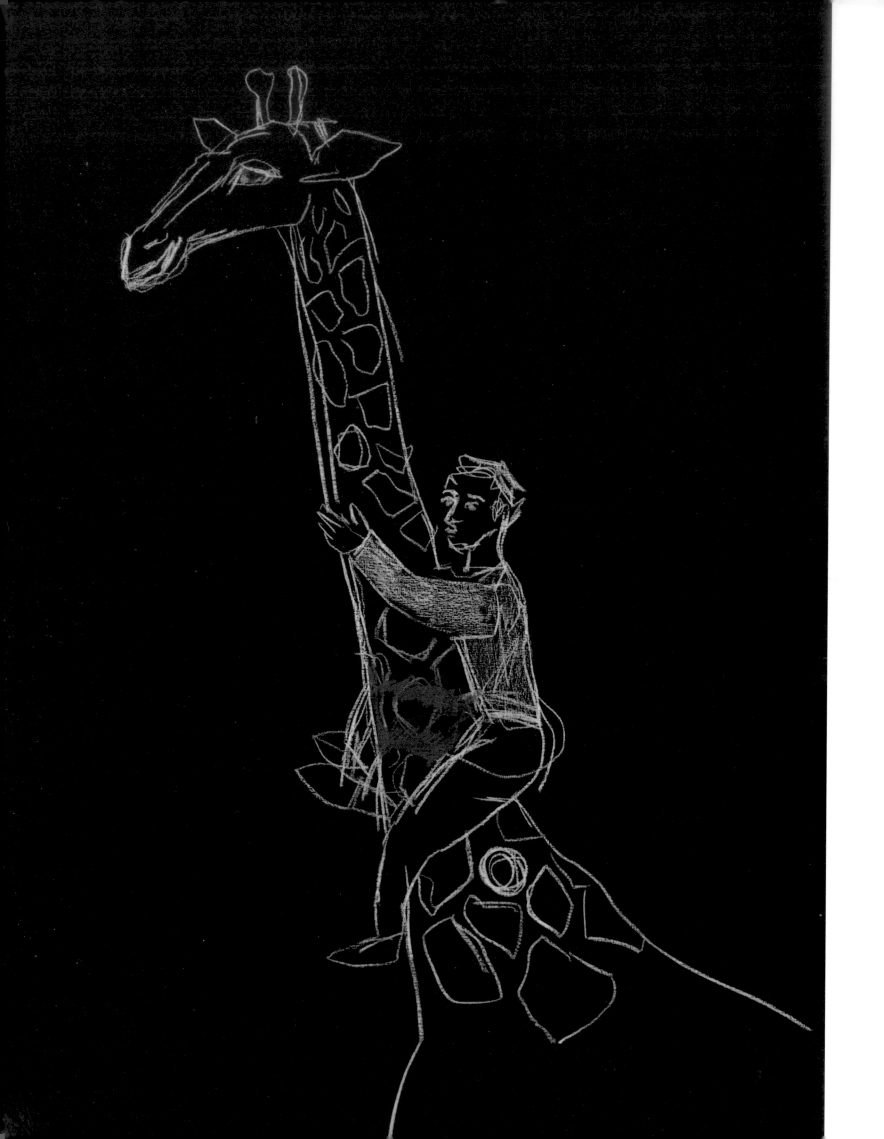